EDWARD McGUIRE, RHA

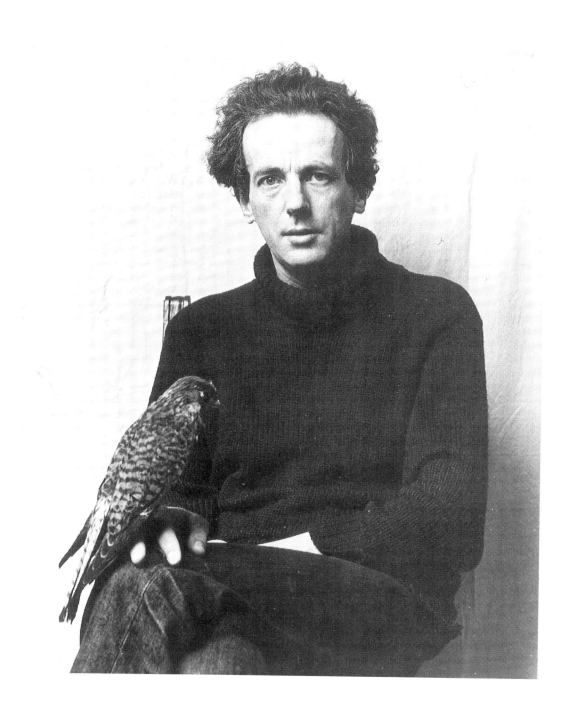

Edward McGuire, Sandycove, 1972
Photograph by Jonathan Harsch

Edward McGuire, RHA

BRIAN FALLON

WITH A CATALOGUE BY

SALLY McGUIRE

AND

POEMS AND MEMOIRS BY
Anthony Cronin, Paul Durcan, Michael Hartnett,
Seamus Heaney, Pearse Hutchinson, Michael Longley,
John Montague and Francis Stuart

FOREWORD BY JAMES WHITE

IRISH ACADEMIC PRESS

This book was set by
Seton Music Graphics, Bantry,
for Irish Academic Press Ltd,
Kill Lane, Blackrock, Co. Dublin.

British Library Cataloguing in Publication Data
Fallon, Brian
Edward McGuire, RHA.
I. Title
759.415

ISBN 0 7165 2478 3

Printed in England by
Abacus (Colour Printers) Ltd, Lowick,
and Billing and Sons Ltd, Worcester

CONTENTS

LIST OF COLOUR PLATES

BLACK AND WHITE ILLUSTRATIONS

The black and white illustrations in the text of the book (as distinct from the Catalogue) include the following works: Self-portrait (1953); Portraits of Julia O'Faolain, Matti Klarwein, 'Rita', Robert Goulet, Cearbhall Ó Dálaigh, Sir Alfred Beit and his wife Clementine, William Whitelaw, Patrick Collins and Monk Gibbon; a sketch of Bruce Arnold; and two still lifes: 'Owl' (1985) and 'Asters'.

ACKNOWLEDGMENTS

MY THANKS are due to the many people who helped me through conversations, writings, the loan of materials, advice, etc. They include the artist's widow, Mrs Sara (Sally) McGuire, John McGuire, Mrs Birgitta McGuire, Barbara and Richard Corballis, Alice O'Connor, Sebastian Ryan, Julia O'Faolain, James White, Patrick Pollen, Eamonn McEnery, Anthony Cronin, Brian Lynch, Paul Durcan, Vincent Poklewski-Koziell, Yolanda Sonnabend, David Hone, Seamus Heaney, Adrian Grant-Morris, John and Patrick Taylor, Ciarán MacGonigal, Patrick MacEntee, Alan Bell, Ted Hickey, Patrick and Penelope Collins, Hugh Charlton, Charles Brady, Geraldine McSwiney, Garech de Brun (Browne), Mrs Oonagh Swift, John Swift, Imogen Stuart, Melanie le Brocquy, Tony O'Riordan, Sean White, Casimir Stamirski. I regret that the ill health of Edward McGuire's father prevented our meeting. And of course, my special thanks to Rita—whose surname and married name I have preferred to keep private.

B.F.

The artist's albums of photographs have been of immense assistance in identifying some works for the Catalogue. I should therefore like to acknowledge the following photographers who took the photographs which are in the albums—Jonathan Harsch, Jonathan Hession and Desmond Barrington. I should also like to thank Katie Donovan, Ida Grehan and Susan Hedigan for checking the catalogue text. John Taylor (of the Taylor Galleries), Ann Stewart (of the National Gallery Library) and Helena Gorey (of the Arts Council/An Chomhairle Ealaíon were kind enough to give me access to sources. I especially thank those collectors and friends who replied to my many letters appealing for information.

All the poets and writers who so generously contributed poems or reminiscences deserve my particular thanks. Michael Hartnett's poem on page 88—the second part of his 'Fairview Park: 6 a.m.'—is reproduced from his *Collected Poems, Volume 1* (1984) by kind permission of the publishers, Raven Arts Press.

S. McG.

LIST OF SPONSORS

Corporate

Aer Lingus
James Adam & Sons
The Arts Council, Dublin
The Arts Council, Belfast
The Bank of Ireland
Bank Brussels Lambert
Tom Caldwell Galleries
Eugene F. Collins & Son
Davy Byrne's
D.B.C.C. Asset Management Ltd
Dresdner International Finance plc
Duke Street Gallery
Dublin 91, European City of Culture
Grogans, Castle Lounge
Hardwicke Ltd
Hibernian Insurance plc
M. Kennedy & Sons Ltd
Principle Management Ltd
Pyms Gallery (London)
Rohan Holdings Ltd
Sandycove Secretarial Services
Taylor Galleries (Dublin)
Wilson Hartnell Group

Private

Malcolm Alexander
Sir Alfred Beit, Bt.
Allan Bell
The Hon. Garech Browne
Frank X. Buckley

Hugh Charlton
Mr & Mrs Richard Corballis
Peter Crilly
Susan & David Hedigan
The Earl of Iveagh
Charles Judd
Mr & Mrs Ib Jorgensen
The Lord Killanin
Clodagh King
Vincent Poklewski-Koziell
Mr & Mrs Peter G. Ledbetter
Patrick MacEntee, SC
Mr & Mrs Brian Mathews
Paul McGuinness
Evanna McGilligan
John F. McGuire
E. A. McGuire
Birgitta McGuire
Avril Mitchel
Mr & Mrs Sean Mulcahy
Conal O'Brien
Mr & Mrs Finbarr O'Donovan
Nigel O'Flaherty
Mairaid O'Lubaigh
Stephen O'Mara
Mr & Mrs Lochlann Quinn
Ann Reihill
Dr Philip Robinson
Richard Sexton
Dr James White
Jane Williams

CHRONOLOGY, AWARDS ETC.

SELECTED EXHIBITIONS

The number of works catalogued is given in brackets.

Irish Exhibition of Living Art 1953 (3);
1954 (4); 1955 (3); 1958 (1); 1959 (3);
1961 (1) 1963 (2); 1971 (1)

Royal Hibernian Academy 1962 (3);
1968 (2); 1970 (3); 1971 (1); 1972 (1);
1973 (2); 1974 (2); 1975 (2); 1976 (3)
1978 (2); 1979 (4); 1982 (6); 1983 (6);
1984 (2); 1985 (2); 1986 (1)

Oireachtas 1973 (1); 1975 (1); 1976 (1)
1977 (1); 1978 (1); 1980 (1)

Dawson Gallery, 'A Recent Painting'
(one-man exhibition) 1969 (1)

David Hendriks Gallery, 'Paintings,
Drawings & Sculpture presented by
Claddagh Records' 1970 (4)

Municipal Gallery of Modern Art, 'The
Irish Imagination, Rosc '71' 1971 (2)

Ulster Museum, 'Artist's Choice'
1973 (14)

Cagnes-sur-Mer, 'VIe Festival
International de la Peinture' 1974 (4)

Academie des Beaux Arts, Paris,
'Concours pour le Prix de Portrait Paul-
Louis Weiller' 1979 (1)

Crawford Municipal Gallery, Cork;
Ulster Museum, Belfast, 'Irish Art
1943–73, Cork Rosc 1980' 1980 (1)

London and Irish Touring Exhibition,
'The Delighted Eye, Irish Painting and
Sculpture of the Seventies' 1980 (2)

Taylor Galleries (one-man exhibition)
1983 (7)

RHA Gallagher Galleries, 'Edward
McGuire, RHA, Retrospective', 1991

PRINCIPAL PUBLIC COLLECTIONS

Ulster Museum, Belfast.

The National Gallery of Ireland, Merrion
Square, Dublin.

The Hugh Lane, Municipal Gallery of
Modern Art, Parnell Square, Dublin.

The National Museum (Presidential
Room), Dublin.

Trinity College, Dublin.

University College, Dublin.

University College Cork.

P.J. Carroll and Co. Ltd, Dublin.

Dublin City University.

PRIVATE COLLECTIONS

In Ireland, England, Spain, Italy, France
and the U.S.A.

FOREWORD

SON OF A SUCCESSFUL, popular and handsome figure in the world of business, sport, politics and art, Edward McGuire instinctively retreated into a private world of his own. He continually moved away from those areas where Ned, his father, shone, and I suspect that his concentration on subjects of realism in his still life or portrait paintings, in which he could achieve a measurable accuracy and perfection, was in response to his inner need to satisfy himself that there was nothing hapazard or accidental about his pictures. His father tended to collect paintings of the modern expressionist style and also to paint in this manner. For his own early pictures, Edward used the name Edward Augustine to break any suggestion of family connection, but eventually when he was happy in his mind that he had carved out a personal style that no one could ever possibly confuse with that of his father, he returned to use his proper name, Edward McGuire, and to sign his pictures accordingly.

The even tonality of his colour harmonies and the intimate nature of his subjects, never similar to the stylistic practices of his contemporaries in the 'Living Art' exhibition, who preferred colour and form compositions inspired by the post-impressionists and cubists, ensured for him a role in the art world of his time whereby he stood out as a unique and separate individual.

His private life did not at all reflect his reclusive isolation as an artist and he enjoyed cutting a dash in the social scene as the author so successfully relates in many amusing incidents. At times, indeed, he was capable of extravagant out-bursts, charitably excused as 'typical Bohemianism', which was perhaps a reflection of the tension engendered by his remarkable and intense studio practices.

During the 19th century when the industrial revolution was in full swing in Britain, painters were relieved of the labour of mixing their own paints. Tin tubes were invented to contain the ready-made material. Brushes, paints, bonding agents, primed canvases, drawing and watercolour equipment, all of which were once amongst the secrets of the artist's studio, were now placed in the hands of unsupervised industries. Above all the quality of paper deteriorated drastically. The mixture of wood pulp and alum and certain other acids resulted in commercial paper products which rapidly aged and lost their colour. Edward McGuire was one of the rare and unique artists in that he would have nothing to do with

such products. He took a remarkable interest in the make-up and structure of all his painting materials and was prepared to spend years developing his technique, and Brian Fallon tells us in this splendid biography how he approached these materials with a craftsman's passion and compiled a colour dictionary over a period of years. As a result his works are most beautifully achieved with a perfect finish and it seems certain that they will survive after great numbers of pictures by modern painters will have lost their original impact and freshness.

As well as his application to the quality of the materials he used, he also carried out an intense research into bones and skulls of dead animals in order to reach an understanding of the basic structure and shape of living creatures, for such was his application to his profession that he told the author he 'wished that the people he painted could be put into a fridge and taken out again when he needed them'. However, he would have been the first to reject the idea of painting a frozen image as he was intent on reflecting in his sitters the thought processes and inner responses which gave animation and life to their countenances.

Partly as a result of this pursuit of extraordinarily minute details of animals, he developed a remarkable skill as a still life painter of birds of various kinds and sometimes introduced such a figure in the background of a portrait as a symbol reflecting some aspect of the character he was engaged on representing.

By the early sixties, many of the conventional portrait painters in Ireland like Sean O'Sullivan, James Sleator and Leo Whelan had passed on and although the demand for official portraits of political, academic and artistic figures remained, a new element had entered into the minds of clients. Should they consider commissioning one of the more innovative artists of the day whose work might reflect current trends and tastes and thus enable the sitter to be seen as a man of cultivation and originality? Yet the controversy in other countries provoked by portraits which many thought failed to represent the outstanding qualities of the sitter, as happened for instance in the case of Graham Sutherland's portrayal of Sir Winston Churchill, gave rise to second thoughts.

Edward McGuire's rise to prominence about this time was opportune. His work combined a high degree of elegant presentation and artistic finish with a deep penetrating insight into the representation of character. His colour plan also gave his pictures a new modern feeling by the way in which he combined tones of yellows, browns and creams for flesh, never allowing greys beloved of the academics to represent the gradations which we all recognise as belonging to photographs. In the same way too he treated all colours for the costumes or for the furnishings in backgrounds, with such delicate shadings of the chosen colour, that no matter how closely we examine the surfaces we shall be unable to find those fine infusions of grey formerly used to delineate shadows. It is

quite remarkable that if one sets out to visually penetrate the wooden floorboards beneath a sitter's feet in one of his pictures, one will discover that he achieves perfect verisimilitude without ever introducing a colour other than is proper to wood. And so his place in our artistic history seems to have been achieved by the developement of a new kind of portrait painting which at first sight seems to differ little from the portrait painting which preceded his arrival except for the fact that he had developed a method of projecting the realism of appearance but without for a moment invoking the colour system of academic tradition in which grey is infused with pure colours to create shading.

From the scrupulous observation which he appeared to direct on the countenance of his sitter he seemed able to set down a most remarkable lifelike image on his canvas, almost as if in the tension set up between the intensity of his gaze and the long, slow hours of minute recording of each participle of the face before him, he succeeded in achieving images which go a long way towards making an exact record of how the people of his own time appeared to their contemporaries. The tension which his method seems to have achieved is a solution of the conflicting impulses which he must have recognised in the many poets he painted. These conflicting impulses of the life and work of the poet are presumably similar to those of such a painter as he himself was, and in his best works he achieved a kind of equilibrium in his pictures which lifts them up into a realm of artistic harmony which is of course the aim of the committed artist.

Every artist is a contemplative who uses, as the author points out 'the true ascetic's need for withdrawal and contemplation' and in such periods of inner reflection reaches conclusions which enable him in a moment of vision to solve the problem of bringing together all the factors which will result in an image which combines both the living appearance and the inner compulsions of a compelling personality.

JAMES WHITE

INTRODUCTION

EDWARD MCGUIRE WAS, in my opinion, the finest Irish portrait painter of his generation, and was possibly the finest Irish portraitist since John Butler Yeats. The parallel with Yeats is not carelessly chosen, since he too was a painter with a peculiar insight and sympathy towards literary men, which made him a visual recorder of the Irish Literary Renaissance: his poet son W.B. Yeats, George Moore, Syngé, Æ, Douglas Hyde, Padraic Colum are among the writers he painted. Edward McGuire played a similar role towards the Irish intelligentsia of the 1960s and 1970s, and he also portrayed older figures such as Patrick Kavanagh, Seán O'Faoláin, Francis Stuart, Benedict Kiely and Monk Gibbon. Both he and Yeats left entire portrait galleries of a generation or, in McGuire's case, of two generations. A further parallel between them was their slowness and their capacity for sometimes crippling self-criticism, leading to a limited output, though of high quality.

Irish portraiture has been dominated by the tradition created by William Orpen, a painter of great gifts, but a man for whom art was a profession rather than a vocation. His technique was 'painterly', rapid, highly knowledgeable and fashionably brilliant, with that quality of bravura which the *Belle Époque*—Orpen's real era, rather than the 1920s—loved so much in its art, its social life, its dress and its public personalities. Orpen was a born virtuoso and also a daemonic worker, who by his late teens had mastered the skills of the schools, from Velázquez to Manet. His international prestige and personal magnetism made him a formidable teacher, particularly of the generation of Irish artists who immediately followed him—Keating, Tuohy, Sleator etc. Yet the legacy turned sour in the end; the annual exhibitions of the Royal Hibernian Academy were dominated by his style and his followers long after his death, and long after it ceased to be modern (insofar as it ever was) and had declined into formulae. *Belle Époque* brilliance was keyed down into Free State smugness and provincialism; with a few exceptions the portraits of bishops, high-ranking civil servants, lawyers and socialites, turned out so industriously and mechanically, make dreary viewing today.

In some ways, this was less the fault of the artists themselves than of the patrons who employed them. Portraiture was sometimes the bread-and-butter

of talented men (and a few women too) who in their hearts would have liked to paint more landscapes, still life and genre pieces, and fewer of what Sargent called 'mugs'. But the gallery system as we know it today scarcely existed in Dublin between the two world wars, and not until the appearance of Victor Waddington did Ireland have a dealer and gallery-owner of real calibre. By the time it did, the artistic climate had changed, mainly as the result of the founding of the Irish Exhibition of Living Art in 1943. This marked the official birth of Modernism in Ireland, though of course it had existed unofficially since the 1920s, if not even earlier. And when abstract art took root from the 1950s onwards, portrait painting was sidelined—mainly to the annual RHA exhibitions, whose artistic prestige had by then declined considerably, although they remained social events for a certain type of culture-hunting philistine.

All of this socio-artistic history is not only relevant to the career of Edward McGuire; it is essential to understand the overall cultural background against which he worked. Apart from hanging a few of his early works, the Living Art Exhibition never gave him the role or prominence he deserved among his peers such as Camille Souter, Gerda Frömel, etc. Modernist snobbery declared portraiture to be old hat, unless it was so stylised that it became unrecognisable, and there was even a period in the IELA's history when it seemed bent on showing virtually no work that was not abstract. The term 'Post-Modernism' had not yet been coined, and even when it was it took a long time to register with the Dublin intelligentsia. McGuire was, in fact, ahead of his Irish milieu, since he was a genuine Post-Modernist by instinct and conviction. A glance at the trends and achievements of the past fifteen years or so will bear this out. Post-Modernism has brought back Lucian Freud (McGuire's one-time teacher at the Slade) into prominence; it has also produced Photo-Realism, a movement with which his own style has a good deal in common. But the callow, opportunistic, pseudo-Modernists who formed the core of the Living Art from the middle Sixties onwards, were quite incapable of realising the fact, or of recognising McGuire's real originality. As a result, he was forced to exhibit for years in the RHA, which with all its faults proved more catholic in its policy than the IELA, and was prepared to allow a certain number of Modernists and even Post-Modernists to show alongside the Old Guard of the academicians.

This factor coloured public perceptions of him as an artist, making him seem to many viewers either an academic portraitist, or an interesting eccentric. McGuire was neither; he was a thoroughly contemporary painter who found himself isolated against his will. If he were alive today—and given a normal span, he should be—his essentially Post-Modernist stance would be understood, and he would be honoured accordingly.

Of course it would be a gross exaggeration to say that he was generally

ignored or misunderstood by his fellow-painters, or even by the critics and collectors. In fact, from relatively early in his career, his work was eagerly sought after; he was included in several prestige exhibitions of Irish art abroad, including the 'Irish Imagination' which was seen in America in 1971, and the 'Delighted Eye' exhibition mounted in London in 1980. A minority—but a significant minority—of artists admired him; most critics praised him, and he won various awards and public tokens of recognition. Yet he remained an outsider, always more at home with writers than with painters and sculptors, among whom he was rather an uneasy figure. He was, for one thing, better educated in almost every sense than the average visual artist; McGuire was a deeply cultured man, even though I do not think he read a great deal, apart from a number of favourite works which he went through over and over again (Pissarro's letters to his son was one of his bibles). He was a great hunter of museums in his earlier years, a man who thought and theorised deeply about his art and even spent years of his life on his 'colour dictionary', a work which deserves a detailed study in its own right. McGuire possessed a fine and lucid intellect and an almost over-developed critical sense; he was a man who would have been thoroughly at home in Renaissance Florence, and he even looked the part. Given the proper period clothes, he could almost have walked out of the frame of a portrait by Bronzino.

Although McGuire studied art while still an adolescent, he emerged as a painter relatively later (another thing he has in common with John Butler Yeats, incidentally). There were entire years in which he did little except tinker at his craft and which produced very little in the way of finished paintings, though several of his early works were destroyed. His really creative period only began with the superb portrait (pl. 4) of Garech Browne (de Brun) on which he laboured obsessively before it was exhibited at the RHA annual exhibition in 1970. He was then in his later thirties, and since he died in his mid-fifties, his maturity lasted only a decade and a half; Edward's elaborate, almost painfully slow methods of working did not allow him to produce more than a handful of paintings a year (though in the last few years of his life he tried at times to work faster, and the work suffered accordingly). Given another ten or twelve years of reasonable productivity, without commercial or other strains, what might he have produced? The possibility does not bear thinking about.

A man of Edward's perfectionist, rather obsessive temperament should never have been driven into the field of commercial portraiture. Many, or most, of his best portraits were painted by his own choice, not by commission: he even made this point himself in an official application to the newly-founded artistic and writer's body, Aosdána, in 1984. In certain cases, of course, the writer concerned made the overtures, but in general Edward himself made the first move, directly

or through emissaries. He chose and selected; he was like a theatre producer who chooses the play he likes.

Though as a critic I knew Edward's work over a long time, and had met him occasionally at exhibition openings[1] and the like, I only got to know him intimately in the last ten years of his life. He seems to me, in retrospect, one of the most remarkable people I have known; though in nearly thirty years in art criticism I have met a wide cross-section of artists, writers, politicians, and that dubious genre of mankind known as 'celebrities'. Edward had innate personality; it was obvious straightaway in everything he said and did, even in his physical movements, and many people who never met one another have testified to this quality which he gave out quite unconsciously, like an invisible radiation. He possessed a sympathetic magnetism which was equally effective with men and women, earning him the friendship of people who might know little, or nothing at all, about art and artists, but who were drawn to him personally. His patrician looks, debonair manners and innately sensitive, affectionate nature could make him quite irresistible (and in his earlier years, in particular, there were a number of women who made no effort to resist him). But there was another side to the picture, and since I am now the portraitist I shall not shirk setting it down. If he was an affectionate friend, he was also a good hater, and he was not a man to hide his antipathies or cloak his opinions. Edward, in fact, could be rude, sarcastic, cutting, sometimes on quite public occasions too. Very often the recipients of his rudeness deserved what they got, but it remains true that he not only made enemies that way, he also alienated friends, at times for good. His nervous, highly-strung, over-sensitive temperament sometimes made him imagine slights or hostility when neither was meant. He had a complex nature, at once outgoing and introspective, the kind which bruises easily and can be forced in on itself. Henry James says in *The Bostonians* that the world is divided between people who take things easy, and those who take things hard; Edward belonged to the second category.

I suspect that, ultimately, even his closest friends only knew him up to where his private domain began, to which nobody was admitted. Outwardly outspoken, he was inwardly reticent. In the later stages of our friendship (during which he painted my portrait) I became fairly intimate with him, but though he might talk for hours at a stretch, there were whole areas of his private life which he never spoke about, not did I encourage him to do so. Partly, no doubt, this was a reflection of the public-school ethic under which he was educated, and of his upper-middle class upbringing, but I believe that it was first nature as well as second with him. This is why, in the following chapters, I have relied so

1 He was not a regular attender at such events.

much on the descriptions and testimony of others, rather than his own. (Not that I had much choice, since surviving letters by him are as rare as Roman coins in old Irish sites.)

EARLY DAYS

EDWARD AUGUSTINE MCGUIRE was born in a Dublin nursing home (now vanished)[2] on 10 April 1932, the second son and third child of Edward McGuire and his wife Bridget ('Billie') whose maiden name was Neary and was from Newry, Co. Down. His brother John was the oldest of the McGuire children; then came Edward's sister Barbara (now Mrs Corballis), then Edward himself, and finally a younger sister, Avril. The family lived then in Foxrock but later they moved to a large house and grounds at Newtown Park, Blackrock. The outer Dublin suburbs were not the huddle of housing estates they largely are today, now that developers have carved up almost all the eligible sites, and open spaces have shrunk and shrunk. In the early thirties, Dublin was a smallish city with open country pressing in on all sides.

Edward's father, who is still living, was and is one of the best-known Irishmen of his generation. A successful businessman, for years a senator, a one-time tennis international, a social figure and pillar of society, he owned one of Dublin's most prestigious stores, Brown Thomas of Grafton street, which still exists though it has passed into other hands. It was founded in the first half of the nineteenth century by two Englishmen, Brown and Thomas, who built up a successful drapery business. In 1928 it was acquired by Selfridges, but in 1933 came back into Irish hands when it was bought by Edward's grandfather, John A. McGuire,[3] an energetic self-made man who modernised and expanded it. His even more dynamic son followed this policy and even—it must have been a bold innovation at the time—hired a well-known painter, Norah McGuinness, to do the firm's window design. Edward McGuire Senior was a talented artist in his own right, who exhibited regularly and sometimes in very distinguished company; he also owned a good collection of paintings, including modern ones, and collected *objets d'art*. It was a good environment for a future painter to grow up in, and John McGuire remembers that his father had a good many art books, some of them in colour—which must have been relatively rare at the time.

For his parents, however, the problem was not what Edward would be when

2 In Hatch Street, according to some of his family; in Upper Fitzwilliam Street, according to his sister, Mrs Barbara Corballis. Edward's birth certificate simply says 'Dublin'.
3 The family came from Waterford, but traced themselves back to Co. Fermanagh.

he grew up; it was whether or not he would live to grow up at all. He was found to have a heart murmur, and few people expected him to live to see his twenty-first birthday. For that reason he did not go to school until he was well into his teens and was taught by a private tutor, a Mr Anderson (who, I understand, is still living). He seems to have been a child with a particularly sweet and affectionate nature—'too good to live', according to his sister Barbara. She remembers him sitting up in bed suffering from some sort of asthma attack, aged about nine, in his pyjamas with his face framed in curls.

'They said he would never reach twenty-one', she says. 'That is why my mother took such care of him—we all took care of him. We didn't mind him getting the breast of chicken. When he did go to school, he was sent with strict instructions not to play games, but in fact he played everything.' The school was St Conleth's in Clyde Road, Dublin, where he went aged twelve and stayed a year and a half. He was a day pupil, and seems to have been a normal, well-balanced boy, with no trace of morbidity or nerves.

The children's nanny, Alice O'Connor, joined the household in the year of his birth and has been in the family service for fifty-eight years. She remembers Edward as 'very affectionate', but never clinging or effeminate—'well able to fight his corner when he had to'. She says he was also 'wonderful at games', a legacy from his father who had been a tennis international and was also a keen cricketer. Friendly cricket matches were played regularly at Newtown Park, followed by communal meals for both teams, and Edward proved from early on to be a natural athlete. He had perfect co-ordination in all that he did, and perfect timing in hitting a cricket ball or a tennis ball; he also played rugby for a time and

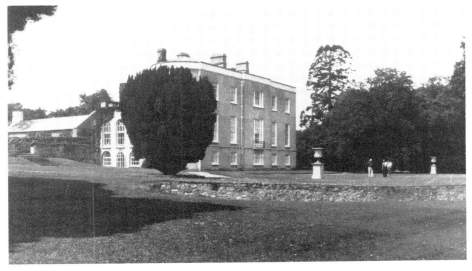

Newtown Park House, the McGuire family home

23

years later his friend Eamonn McEnery, teaching him how to handle a gun, found that Edward was that rare thing, a born and natural shot.

Alice O'Connor has on her wall a large portrait of the four McGuire children, painted by Gaetano de Gennaro, an Italian society portraitist who had been caught in Britain by the outbreak of World War II and moved to Ireland, which was nominally neutral though secretly pro-Allies. The depiction of Edward bears out the description of him—curly-haired, wide-eyed and with an open, almost angelic look. His mother, she recalls, 'loved them all', but Edward was her favourite. She also has a photograph of him, aged about eleven, painting the story of Snow White and the Seven Dwarfs in watercolour, helped by his sister Avril whom he called 'his little slave', and who did the chores. Walt Disney's film had made the fairy-tale familiar to millions of children who had never read the story. Edward himself also produced a series of cartoons about an imaginary family called the Schlongs, done in rather spidery black-and-white, which is now in the possession of his widow, Sara ('Sally').

At the age of fourteen he was sent as a boarder to Downside School in Somerset, a major change for a boy who had never left home before, let alone Ireland. Downside, with its impressive church, ranked as one of the elite Catholic public schools in England, along with Stoneyhurst, Beaumont and Ampleforth, and was run by the Benedictine order. He went there in 1946 and stayed until 1950, showing more interest in sport than in academic subjects. Downside had a fairly large Irish contingent, concentrated in Roberts House, where Edward too was quartered. A school friend, Sebastian Ryan (who has written a lively little memoir of Edward for the *Martello* magazine), has given me an account of him as a fellow-pupil there:

> Without being in the least stand-offish, he was a detached, slightly aloof figure and not particularly communicative except with one close friend, David Wright. We were in different classes, so I knew little about his prowess as a student; he had no reputation as a scholar, but neither was he talked of as a dunce. I expect he did the minimal amount of work, just enough to keep him out of trouble.
>
> Unlike the 'hard men' of the school who tested authority to its limit, he was not on any prefect's hit list. He was not a known smoker, drinker or one of the group of bravos who essayed clumsy dalliance with the local village girls. He was a supremely elegant figure and when we shed the funeral black of the winter terms for the light grey flannel of summer, I envied his well-cut suits (from Brown Thomas, I suspect, rather than the school tailor). Sports was the only area in which Edward showed much interest, though without being a 'hearty'—and he just

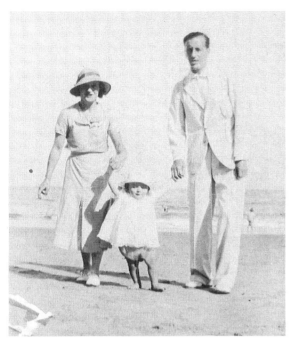

Edward with his father and mother, 1933

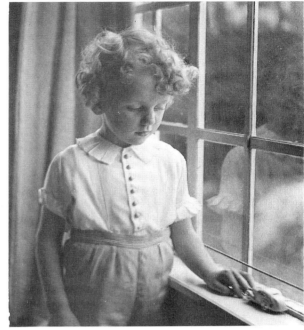

Edward at the age of three

happened to have a natural talent for them which he enjoyed exercising. I used to watch him play tennis with Reggie O'Reilly, and it was clear that he had been well coached. He was a reluctant conscript to the rugby field. He was given a trial at full back for the first XV only because of his dexterity in gathering loose balls and booting them powerfully into touch. He was reluctant to run around any more than he considered reasonable, and still less to be rolled in the mud.

The boy whose health had been once despaired of had grown into a sinewy six-footer,[4] slender but strong. Edward's physical strength and athleticism were well known in later years, when even known and feared bohemian brawlers were careful not to pick a fight with him. He himself rather prided himself on being cricket captain of his school and twenty years after he had left it, he told an interviewer proudly that he had been 'first in the Downside batting averages'. In Ireland he was later chosen to play for the Leprechauns—a real distinction— and he was for years a member of the Phoenix Cricket Club, whose grounds are in the Phoenix Park in Dublin. His brother John says that he never really applied himself to any sport, but had 'a lovely natural style'.

4 As an adult, Edward's height was six foot one.

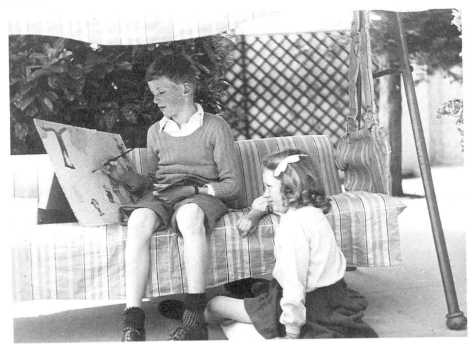

Edward with his sister Avril, painting in the garden

'The McGuire Children' by Gaetano de Gennaro, early 1940s

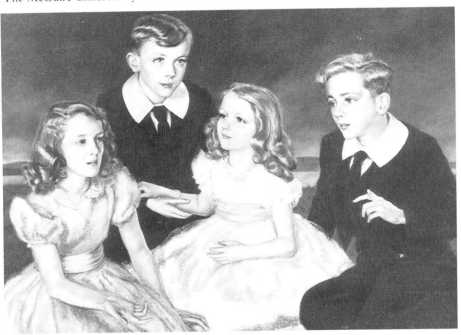

Edward was always a reluctant letter-writer, except to a very few people, but one of his few surviving letters home was written after learning of the death of his paternal grandmother. It was dated Monday, February 2nd; the year is not given but it must have been 1949. The letter reads:

My dear Mummie and Daddy:

Thank you so much for your letter, it was wonderful talking to you on the 'phone, I must do it again sometime, I shall let you know what night (by telegram).

I was so happy to hear that Grannie died so happily, and that Gran-daddy is not upset. I'm sure she she went straight to heaven—she was an absolute saint. I pray for her continuously.

I am doing very well at hockey, I am on the first game [team?]. We had a match on Saturday, we lost 2-1. To-day, Monday, I am in bed—it is nothing to worry about. Last night I woke up with an ear-ache. It is not so bad to-day. Matron brought me in here this morn-ing: a lot of boys are in bed with flu etc, of course this is the term when everybody gets colds etc.

Oh! Could you possibly send me some chocolates? Not sweets, because chocolate is more filling and I have run out of it, but still have some more sweets; could you send them this week if possible—thank you very much. We have a new housekeeper, she is not doing the food so well as last term.

I am progressing with my music. My clarinet is getting grand. Please excuse this awful writing. I am writing it in bed. Fr——[illeg-ible] was delighted to hear about you both coming over. Could you tell me the exact date that you are coming, so that I can book a place in the guest house.

My room is really great, it will be grand when I have some pictures; little things like mirror, curtains etc. are very useful. Do not worry about the curtains, I know that they take a long time to make out and get sent off. Well Mummie and Daddy I must stop now. I shall write soon. All my love to you both, & to all the others. Lots of love

Edward

It should be added that his school friends remembered one more essential aspect of Edward's personality—his courtesy and good manners, which were innate. Just as he could look elegant even in old clothes, Edward was innately courteous in a way which went far beyond the bland, facile charm so common among public-school products. He was more aristocratic than most aristocrats, and his patrician looks and carriage were often remarked on (his father, by the

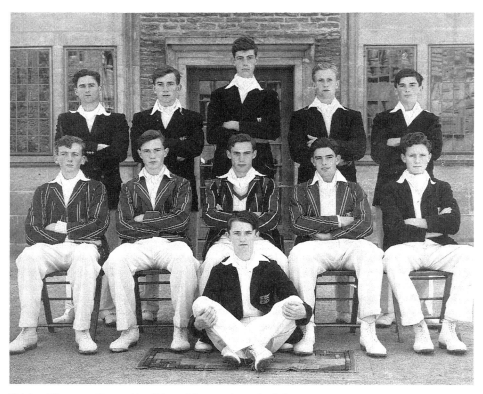

Cricket Eleven at Downside; Edward is seated on the left

way, was equally impressive: I remember, as a young journalist, watching him in some Senate debate and thinking that he looked more like a Roman senator than an Irish one).

ITALY AND ART

IN HIS OWN WORDS, Edward 'grew up surrounded by art'. His father's collection included works by Dérain and Vlaminck, and Edward McGuire Senior was also one of the influential people who had helped to popularise French Modernism in Ireland, through exhibitions and discussions (he even lectured to students in the National College of Art and Design on the subject, in 1940). The elder McGuire was not, strictly speaking, a professional painter, but he was no Sunday dauber either; he showed alongside 'name' artists, was a friend of Jack Yeats, and had at least one exhibition of his own work at the now-vanished Dublin Painters' Gallery. Edward on one occasion, at least, is known to have praised his father's work at the expense of his own, though he might not have liked others to do so.

The fact remains that when he left school, he seems to have had no special idea of what he would do with his life. His early attempts to paint and draw were hardly exceptional, they were what many gifted and imaginative children do, without growing up to be full-time artists. The decisive element seems to have been a visit he made, aged eighteen, to Italy with his father. Years later he wrote that this visit 'made me very certain of my ambition, but slightly dismayed by my decision'. They stayed in a friend's villa at Florence, and through his father—who had an enormous range of friends and acquaintances, social, sporting, financial and artistic—he met Bernard Berenson and called on Harold Acton, one of the last in the great line of English aesthetes. The visit was one of the determining features in Edward's life, and the experience of seeing the Italian Renaissance masters at first hand brought to the surface his innate sense of vocation. For the rest of his life, he was hooked.

Florentine painting, in any case, would have been temperamentally close to him. His Leonardo-like fastidiousness and urge to intellectualise the painting process, his love of order and discipline (in work, at least), his innate tendency to theorise and his relative lack of interest in the more sensuous qualities of painting—all these are Florentine characteristics. In another age he would have been happy working in the studio of Paolo Uccello or Piero della Francesca, discussing the mysteries of perspective or the qualities of the Golden Section. It was this side of him that eventually found an outlet in his colour dictionary. His

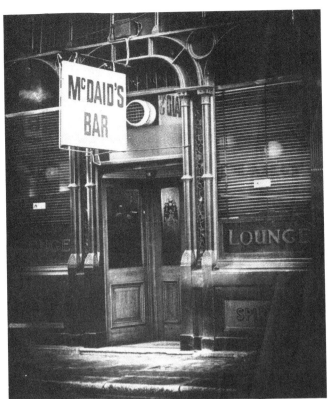

McDaid's Bar, Harry Street, Dublin

Edward McGuire senior,
with his wife Billie,
at an exhibition of his paintings in Dublin,
(from a newspaper cutting)

Edward with his 1929 baby Austin
tourer, Rome, 1951
(from an Italian newspaper cutting)

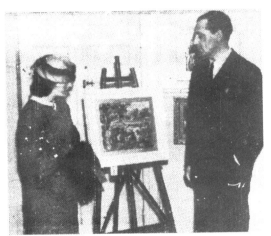

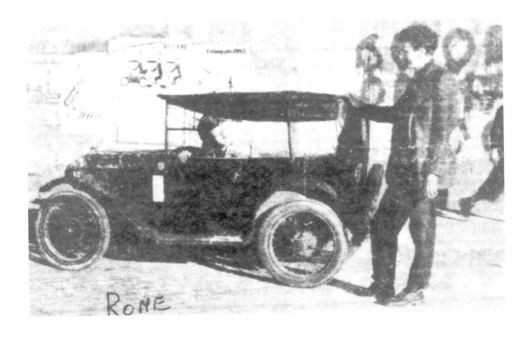

brother John has remarked to me on Edward's love of neatness and method; he was quite the reverse of a slovenly bohemian.

There is some confusion about the chronology here, since various accounts of Edward's career, and some of his own statements to interviewers, give the impression that he went alone to Italy shortly after school, as an art student. In fact, that seems to have come a little later. Before it, and before his family finally agreed that he should study art, there was a tragi-comic attempt to co-opt him into the family business. He began as a 'floor-walker', which was intended to be his first step in management training. From the start, this was a disaster. Edward, in his own way, was proud of Brown Thomas's and the family tradition (he admired his father's abilities and worldly success enormously), but his heart was not in shops, and no one was less suited to a business career. He was a misfit, the job bored him intolerably, and he soon developed the habit of dodging around the corner into Davy Byrne's or The Bailey for his favourite tipple, a bottle of stout. These were 'arty' pubs in those days, without the bohemian shabbiness of McDaid's across the road, and he found congenial company there. According to Sebastian Ryan, there was one farcical episode in which he told a would-be customer that a certain costly gent's cardigan was genuinely all wool, 'including the buttons'. On several occasions the shop assistants, seeing him wandering around uneasily and not recognising him, approached and asked, 'Can I help you, Sir?'

Edward, it was plain, would never make a company director, or even a store department manager. His father agreed that he should go to Italy, to further his education. So Edward brought a battered Baby Austin tourer (which may have been as old as 1929), hiding it at his sister Barbara's house (she was by now married to Richard Corballis) so that his mother should not see it or know of its existence. How he got it across the sea to the Continent I do not know—car ferries from Ireland were still rare at the time—but he did, and drove it across France into Italy. A cutting survives from an unidentified Italian newspaper, dated 1951, showing a photograph of Edward standing proudly beside his veteran car in Rome. The caption reads: 'Il singalare viaggio di un pittore—Edward Augustin [sic] e arrivato a Rome de Doblino, dopo aver attraversato l'Europa, a bordo di una vecchin Austin. Tranne che in montagne (dove spesso occorrare il rinforzo de un asinello) la macchiata riesce a portare due persone a vertiginosa velocita'. ('The remarkable journey of a painter—Edward Augustin[5] who has arrived in Rome from Dublin, after having crossed Europe in an old Austin. Except in the mountains—where at times it needed the extra power of a donkey—

5 Edward's early pictures were exhibited under this alias at the Irish Exhibition of Living Art. Since his father also exhibited there, and they had the same christian name and initials, he may have done so to avoid confusion; but I suspect that shyness may also have been a factor.

the machine managed to carry two people at breakneck speed.') Edward himself said that the car never went faster than thirty miles an hour 'but with a following wind would reach forty'.

His mother, like a good Irish Catholic of the period, worried about his physical and moral well-being, even arranging for a certain order of nuns to look after him, but Edward lived his own life in Italy and enjoyed his independence. Since he was supposed to study art, he did attend the Accademia di Belle Arti in Rome, and he also took some lessons from the fashionable portrait painter Pietro Annigoni (who became a celebrity in England in the 1950s when he painted Queen Elizabeth II). But Edward, from first to last, was essentially antipathetic to all institutions and got little profit from them. Later he was fond of quoting the phrase 'a self-taught artist has learned from an ignorant man', yet the fact remains that essentially he was self-taught. He would have learned the rudiments of painting from his father, who had his own studio at home, and in Rome he presumably attended life class and drew from the usual antique casts. But the elder McGuire's style of painting, influenced by Jack Yeats, was utterly unlike Edward's flat-surfaced, low-toned technique; so was Annigoni's glossy, meretricious academicism.

He learned most from studying Old Masters, while driving about Italy, making long stays in Florence and going south on various occasions to Positano, near Naples. He was painting as well as studying and observing, and Sebastian Ryan is reasonably certain that an Italian landscape, which he saw a few years later in Edward's studio in Blackrock, was painted about this time, and that it was probably of Positano. An early self-portrait, which I have not seen, has survived from this period, though the landscape itself seems to have vanished. A guide to the Uffizi he used has notes in his handwriting, referring in particular to a Fra Angelico painting and comparing it with others he had seen. Like most practising artists, he was never content with books of reproductions, however good (and few were very good in those days). He had to see his favourite painters at first hand, in the paint-and-canvas (or paint-on-panel) reality, and form his own views on them.

He claimed later to have hired out his car to honeymoon couples when he was hard up, which may have been one of the reasons why it was nicknamed 'The Flying Bedstead'. In fast-moving, ultra-chic Rome, its jogtrotting pace enraged many motorists, while its disreputable appearance scandalised some people and amused others. It was stolen twice and returned minus wheels; once it was dumped in a flowerbed in the Via Veneto and recovered by police. Owners of smart limousines felt insulted when it was parked beside or behind them. Once, when Edward was driving to Naples with some friends, the brakes failed on a steep hill and the passengers thought they were hurtling to disaster, but they

relaxed a few seconds later when a cyclist casually passed them out. Slogans were daubed on the Austin at times, and village boys even pelted it with oranges as it passed through their area.

He made plenty of friends in Rome, some of them lasting ones. One was the writer Julia O'Faoláin, now famous as a novelist, who was studying there. Very kindly, she has written an account for me which I give here, very slightly condensed:

> I met him first in Dublin in some public place—an exhibition perhaps? It was the summer of 1952, shortly before I left for Rome.
>
> I can see him with the eye of memory, emerging from a crowd, then backing into it to bow with evasive and slightly furtive grace. He was lean and vaporous and had a great froth of hair.
>
> Next came what must have been our first dinner in Rome; memorable because of a gaffe which would have put a damper on our friendship. What happened was that I asked if he was one of the Brown Thomas McGuires and he, whose persona just then was of the artist, denied this. His aim, that year, was to be a free spirit and a painter, so:
>
> 'No' he said, 'I'm not.' Thereupon I launched into a bit of Dublin satire, quoting Norah McGuinness, who in those years used to do the Brown Thomas window displays and was as fond as the next woman of biting the hand that fed her. What did she—and I in echo—say? I forget but it must have come close, in an anecdotal, worked-up way, to the sort of thing Edward himself would later say of his father. His short-hand was 'a bloody businessman!' Norah was a vivid gossip. I knew her repertory and was trotting it out, with due acknowledgement of copyright, when Edward said; 'I must stop you. I am one of them.'
>
> This shamed us both, and there was a brief pause to acknowledge out mutual mortification.
>
> Having been on the receiving end of the same sort of inter-tribal side-swipe—Norah's Protestant snobbery had sharpened her thrust— I knew what I'd done. I apologised, but remember thinking that apologies would not help. Then I said, 'You brought that on yourself.'
>
> 'Yes', he acknowledged, 'I did.'
>
> His family, I gathered, was supporting him in Rome. His father was interested in painting, owned paintings and had, presumably, introduced him to the medium. So Edward, being overwhelmed, nineteen (?) years old and impatient, was making a bid to be his own man.
>
> His method was playful. He dressed up. He took on a role. It's a traditional way for the middle-class young to rebel—one thinks of

Baudelaire's dandyism and of how in the sixties a whole generation would resort to it. Then, however, the endeavour would be collective, whereas Edward played it solo. He also had a better arena to play in and his efforts produced a satisfying shock.

Rome in 1952 was anxiously conventional. People wore the most fashionable clothes they could afford and the aim was to look like everyone else, but better. Rich ladies, I recall, were wearing black persian lamb coats and carrying chihuahuas in their sleeve or muff. Donegal tweed was 'in'. Men looked like bankers. Coercive ideals ruled. Among them were the requirements that one stood out as a good figure and be—or be seen to be—decorous, prosperous, and up-to-date. No Italian wanted to be seen in the company of anyone who wasn't. Communists were, if anything, more conformist than right-wingers. Men wore white shirts.

In this setting, Edward's brown Edwardian suit with the outlandish stovepipe trousers, his darkish Viyella shirts and his vintage car shocked. Italy was emerging from post-war squalor and defeat. To have new, modern, streamlined things was everyone's aim. To deliberately wear and drive what looked like hand-me-downs was an almost insolent gesture. It derided what the Italians had been through and their efforts to put it behind them.

Edward was quite unaware of this. He was in the tradition of dandies and eccentrics—a Franco-British tradition. Romans didn't understand him or he them at all.

But he enjoyed amazing them. It was easy to *épater le bourgeois romain*, and indeed his car was photographed and written up in the Roman papers. Crowds of urchins gathered wherever he left it, and whenever it gathered a little dust, someone was sure to write 'lavala'— wash it—with an indignant finger. You must imagine a Rome where there wasn't much traffic and one easily found parking in the Piazza di Spagna.

He introduced me to two sets of friends. One consisted of youths in bankers' suits whom he liked to shock. They had 'surprise parties'— pronounced as if the words were in French—in their parents' comfortable houses, escorted 'nice' girls home at nine o'clock and then rushed back to try and have their way with the doubtful ones, who were often Swedish. They had shiny, new scooters or very tiny cars and were endowed with every known prejudice. I suppose he must have had an introduction to them or perhaps known some connection of theirs in school. He was, I think, moving away from them when I

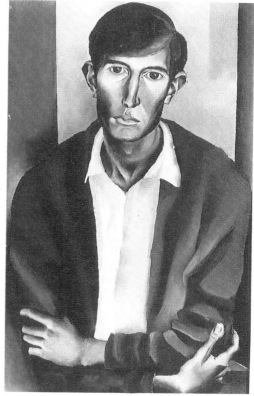

Portrait of Julia O'Faolain, 1984

Portrait of Matti Klarwein, 1953

arrived, but the previous year he had spent time in a villa belonging to one of their families in, I think, Ponza—unless it was Positano?

His other friends belonged to a tiny group of bohemians who had come from elsewhere. The most striking was Vali (?) whose hair was long, red and straight—odder then than now—and who made up her face with a clown-white base and heavy black eye make-up. She had newspaper clippings showing herself and Juliette Greco at the Existentialists' Paris of some years before. She danced and drew and was, I think, originally Australian. She had an Austrian art-school friend called Rudi and when they, Edward and a Palestinian art-school friend called Matti shared a table in the cafe or trattoria, they drew all eyes and were sometimes written up in papers like *Il Messagero* and/or the *Rome Daily American*.

Yolanda Sonnabend, who later knew Edward at art college in London, had met Julia at Rome University, when she was about seventeen, and they became

close friends. She recalls him as handsome, tall, with curly fair[6] hair, often gay, wild, and noted for his erratic driving. Today she lives in London and is well known as a painter and stage designer. I shall return to her in a later chapter; meanwhile, let Julia O'Faoláin have the final words:

> Two last dredgings from that year concern the portrait which Edward tried to paint of me but which I never saw. He was secretive about what was on his easel, and although I remember sitting for him a number of times, I didn't see the canvas until he had wiped me out and replaced me by a bird. His studio was a tiny room up a lot of stairs in either the via Margurra or the via del Babuino.
>
> The other is more elusive. It has to do with his metamorphosis over the Christmas holidays, during which he went home to Dublin and his mother died. It was only years later that he told me how distressing the circumstances had been. At the time, he was depressed, withdrawn, choleric and, I remember thinking, Stephen Dedalus–like. I had known a number of Dedalus-type of men at UCD and was disappointed when the affable and charming Edward of my first few months in Rome returned transformed. The old affability was there still but was erratic and could no longer be relied upon.

Matti—whose personality everybody seems to remember, but whose surname nobody can recall[7]—became a close friend of Edward's for several years and was painted by him (the picture survives). Later, after losing touch for a long time, they met in Paris and went on the town together, celebrating their reunion so intensively that Edward lost the overcoat in which he had put his friend's address. As a result, they lost contact all over again.

Meanwhile, as Julia O'Faoláin says, his mother died, an event which marked a watershed in his life. He had been her favourite, and was very close to her— to the extent, almost, of being a 'mother's boy'— and relied on her for the kind of domestic affection which his busy, socialite father was not in a position to give. Italy was never to be quite the same again, and not long afterwards Edward returned home to Dublin. Presumably he went via Paris, where he now had a girlfriend—his first real affair, both in the physical and emotional sense. Back in Dublin, he had a final fling with his ancient Austin, driving it in a veteran car rally before selling it for five pounds. It was a symbolic gesture; his Italian chapter, one of the happiest in his life, had ended.

6 Edward's hair was in fact dark.
7 He later became a portrait painter in Hollywood, where David Niven was one of his sitters. Bruce Arnold, who owns Edward's portrait of Matti, says his surname was Klarwein. He was told this by Edward personally.

HOME AND THE SLADE

HIS OLD SCHOOL FRIEND Sebastian Ryan, who had not seen Edward for four years (Ryan had left Downside a year before him), renewed contact in the autumn of 1953, shortly after his return. He found him more talkative and out-going than before, reminiscing about Italy and his friends there, or planning schemes by which the two of them could get to Paris and Edward could take up again with his girl friend. But he also talked a lot about art, either art in general or his own paintings in particular: 'he knew that painting pictures was to be his business in life.' Yet the only finished painting in his studio was the Positano landscape already mentioned, which Ryan remembers as being 'astonishingly mature'; he had started a portrait of his friend Vincent Poklewski-Koziell, but he had not progressed beyond the bare outline. Ryan also noted that Edward had developed a formidable thirst and drank a lot, 'but he had a cast-iron head and long, hollow legs and seldom showed outward signs of being the worse for drink. If he did it was briefly, for he had remarkable powers of recovery.'

The studio, by the way, was over the coach-house (strictly speaking, the har-ness room) in Newtown Park. Edward enlarged it by battering down walls or partitions with a sledge-hammer, just as he later battered a large hole in a wall of his famous Leeson Street flat. He often brought his friends home and, accord-ing to Ryan, 'he was agile and quick-witted in slotting them into their appro-priate category. There were those who were presentable, those who were not, and those who fluctuated between, depending on their condition. The former were introduced to the family, and the latter smuggled into Edward's studio above the coach-house.' There were some tensions at home; though Edward's father continued to support him, his younger son had still little to show for his studies. As Ryan says, 'painters are supposed to produce paintings and if they don't, well, what's going on? Not much was going out of the studio, but Edward's behaviour was becoming unpredictable and at times outrageous. The cellar was frequently raided, cars returned banged up or dry of petrol, various lares et penates were inexplicably absent for long periods.' I have also seen a letter written to Edward years later in which an old friend, now a successful art dealer in London, recalled the gay old days of 'falling into the senator's swimming-pool and drinking his gin'.

Edward now had a new friend, the stained-glass artist Patrick Pollen, who was slightly older than he and was an English Catholic by background, related on his mother's side to the Baring family. Often he, Edward and Ryan would make up a threesome and do the rounds of Dublin's (strictly limited) night life. In the summer of 1954, they were drinking in the bar of The Bailey in Duke Street when they spotted a young man whom they knew slightly, in company with a dark, notably attractive girl in a close-fitting black dress. They joined the couple and Ryan and Pollen were ready to bow out 'after a decent interval', but Edward was obviously smitten by the girl, and she by him. They ended up driving to a *bona fide* (that is, a pub or hotel outside the legal city limit, where people could legally drink as 'travellers'). After that, Edward insisted that they should all go back to Newtown Park, where he locked his friends out of his studio and they, in turn, mislaid their car keys in the dark (they were, very likely, fuddled by drink at this stage). Ryan says: 'we were stranded there with both cars in full view of the main house, and the awful prospect loomed that the McGuire family would emerge in the morning to find three dishevelled young men on their driveway.' Edward emerged at dawn, the missing keys were found somehow, and the two cars drove off hastily with Rita—that was the dark girl's name—back in the care of her escort.

This was the beginning of the most intense relationship of Edward's life, until his marriage. Rita lived in London, and it was an open secret to everybody except McGuire Senior that his son's decision to study at the Slade School was largely determined by this factor. He enrolled there in 1954, as a painting student, and meanwhile he and Rita went to live together in a single-roomed flat in Observatory Gardens, between Kensington and Notting Hill Gate (later the poet Derek Mahon lived in the same building). He seems also to have had some kind of studio in or near Cheyne Walk, or perhaps shared it with some fellow-students; certainly Yolanda Sonnabend, who had known him in Rome and was now studying too at the Slade, remembers hectic parties there: 'everybody was slightly wild . . .; one night I got incredibly drunk and they painted my face. I woke up in the morning with this sort of African mask. That was youth. . .' . Like many other people, men and women alike, she was struck by Rita's beauty, dark and exotic and quite un-English.

Rita is now happily married to a journalist in London, but has tender and poignant memories of Edward and when I spoke to her on the phone, she asked me where his grave was so she might visit it. Their relationship, she says, was 'very serious and very romantic', which is borne out by the virtually unanimous verdict of their friends and by members of Edward's family. Vincent Koziell, who saw a good deal of both Edward and Rita at this time, remembers him raising his (full) glass and saying: 'all I want from life is love.' His older sister,

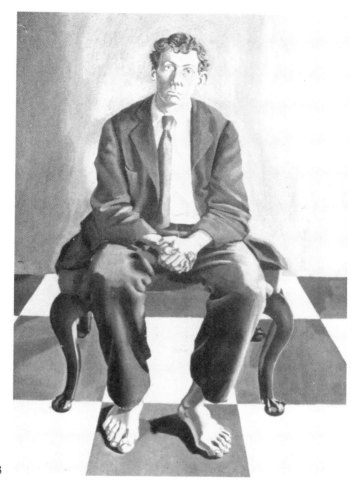

Self-portrait, 1953

Barbara Corballis, also thought Rita very beautiful, as well as 'very gentle and sweet. She was good for Edward too, because she brought out his protective side.' Undoubtedly he wanted to marry her, but though his older brother John says there would have been no real family opposition, there was certainly no encouragement either. Both of them were very young, after all; Edward was living off his father's allowance and Rita herself says: 'there was a thing about becoming a Catholic, and then he was very wild: you know how wild the Irish are, and I think I was a little bit scared of that.' She blames his literary friends for a good deal of his drinking: 'I think he really didn't want to drink as much as he did.' Incidentally, Edward painted a portrait of her, which is now owned by one of his family.

Meanwhile his stay at the Slade was an anti-climax which lasted only some months, and though years later he told an interviewer that he had been 'thrown

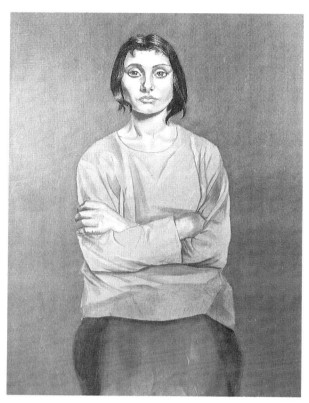

Portrait of a Girl ('Rita') 1955

out', the facts would seem to indicate that he was hardly ever there in the first place. Edward simply was not made for institutions; he could learn and work only on his own, and Lucian Freud, who was one of his teachers there, realised this and told him that he would be better and happier painting alone. Yet Yolanda Sonnabend sensed his innate artistic vocation; 'you always felt he was a painter, not one of those people who were just passing through the Slade.' She has only faint memories of his actual painting, but thought that it was 'very good—very spare.' Edward's own remark that he only went to still-life classes in order to eat the fruit there, sounds like a typical *jeu d'esprit* and should not be taken at its face value.

Though Lucian Freud says today that he cannot remember Edward clearly, and so cannot answer questions about him, there is independent testimony that they met outside college at student parties. There is also proof that he met Francis Bacon about this time, and possibly later, though I have not been able to confirm this with Bacon himself. Edward admired him greatly, but it was Freud who influenced his work; he was also influenced, I should say, by the 'Two Roberts,' the Scottish painters MacBryde and Colquhoun, who were recognised and inseparable characters in the Soho pubs and drinking clubs. Against

the rather grey and drab background of post-war London, a motley crowd of painters, writers, sporting journalists, actors, musicians, eccentrics and oddities of all kinds and many countries created their own Bohemia—a world in which Dylan Thomas had belonged a few years earlier, and which Anthony Cronin has finely depicted in his classic book *Dead as Doornails*. It may have been in some seedy, arty Soho pub[8] that Edward met the Irish painter Patrick Swift, who was five years older than himself and a friend of many writers, including the poet David Wright. Swift had been the young lion of Irish painting before emigrating to London, where he later became involved in the quarterly magazine *X* along with Wright and Cronin. Afterwards he moved to the Algarve region of Portugal, where he lived until his death in 1983.[9]

Swift's work is currently neglected, but I have little doubt that it was the biggest factor in forming Edward's own style, and Anthony Cronin agrees with me. We both had formed this opinion independently, so I felt greatly buttressed in my view to hear from Edward's widow, Sally, that he admitted the debt himself: 'he always said that it was Swift who put him on the right road. (See also his 1973 interview in the *Irish Times* by Harriet Cooke.) But exactly when they first met is now impossible to say; both men are dead and Swift's widow, Mrs Oonagh Swift, says she does not know the details of her late husband's early life. His brother, John Swift, remembers an encounter between them in McDaid's pub in Harry Street, at which Edward joined them, about 1958, when Swift was in Dublin on a visit from London, but almost certainly he and Edward knew each other well before that. Both were friends of the poet Patrick Kavanagh, and the interflow between McDaids and Soho was constant during the Fifties and early Sixties.[10]

Sebastian Ryan saw Edward briefly in London in January 1955, when he was living with Rita, and he met them again later when they passed through Paris with John McGuire, who was treating them to a holiday. 'We had a convivial evening on the Left Bank, but as they neglected to book into a hotel and couldn't get one in the area, I brought them back to my father's flat in the Rue Molière, where they bedded down on various sofas and stayed to lunch the next day.' Rita herself has vivid memories of this trip, for which John not only paid but drove them in his own car as far as Rome. In Ischia, they were eating dinner together in a trattoria when a man sitting at the other end of the room was pointed out to her as W.H. Auden.

Their love affair, however, was burning itself out, partly by its youthful inten-

8 The French Pub was a favourite drinking place.
9 *X* ran for seven issues from 1955 to 1962. It covered visual art as well as poetry and prose, and had some very distinguished contributors, including Beckett and Giacometti.
10 Cf. *Dead as Doornails*, for an account of this bohemian ambience.

Edward McGuire Senior
with his two sons,
Newtown Park, 1950s

sity and partly because of the obstacles and complexities involved. Finally, Edward went back to Dublin, and then on to the Aran Islands, where he stayed a year, living virtually on his own there. They still corresponded, and Edward seems to have made occasional brief forays to London when he could raise the money; but essentially their relationship had passed its apex and was now in a descending arc. Sebastian Ryan says: 'Julia O'Faolain took Rita under her charitable wing, and she and I consoled her as best we could when Edward's visits became shorter and less frequent.' By November 1956, a literary friend was writing to Ryan in France: 'Rita and Edward? He is still in Aran—painting. She rang him after a long period of oblivion. He was distant.' And Yolanda Sonnabend says: 'we all felt that he had treated her rather badly.'

ARAN AND SELF-DISCOVERY

ONE PATTERN WHICH EMERGES in Edward's life, periodically but regularly, is an alternation of almost bohemian gregariousness and solitude. There were areas of his life in which he obviously needed people and human contacts, exchange of ideas, social and communal stimuli, or simply 'fun'. At such times he radiated warmth (and sometimes, too, anger or resentment) and he enjoyed having an audience, or simply being one of a group. This gregarious side of his nature was counterbalanced by an almost monkish withdrawal into his inner self, when he was likely to vanish from his usual haunts and circles, or even from his closest friends and his family. The lengths of these quasi-religious retreats could vary from days to months.[11]

His trip to the Aran Islands in 1955 was an obvious example of this, a year-long stay on Aranmore in which he lived alone, apart from his contacts with the local people and a few visits from friends. The stimulation of Italy, the hectic bohemian interlude in London, and the passionate, emotionally taxing relationship with Rita, all combined to produce a powerful reaction. He simply had to get away from all that and assemble his fragmented inner self again, to think things out on his own, decide on his future. And above all, he wanted to work at his painting in a sustained, purposeful way, not in the spasmodic, disconnected style of the previous few years. His growing self-dissatisfaction demanded that he formulate his own style and his ideas about art as his true vocation and profession. In retrospect, the year on Aran was one of the most important and formative of his whole life, because it was then that he really discovered himself as an artist.

In fact, Edward was a more seasoned painter at this stage of his career than his friends may have realised. He had already exhibited at least twice in the annual Irish Exhibition of Living Art, but under the name 'Edward Augustine'— a self-portrait (1953; see p. 39) and a study of trees (1954). The early self-portrait was mentioned favourably by the respected critic Edward (Ned) Sheehy, who wrote in the *Dublin Magazine*: 'we have an interesting newcomer in Edward Augustine, whose 'Self-portrait' in particular shows him to be a painter whose

11 He was a lifelong lover of Thoreau's book *Walden*—which incidentally, inspired Yeats to write '*The Lake Isle of Innisfree*'.

realism has a curiously tense and nervous quality. I should like to see more of his work.' One of these early paintings has survived, but the other has not: the full-length (rare for him) self-portrait painted in Newtown Park, which showed Edward sitting with bare feet and a disconsolate expression (photographs of this work survive). He later destroyed it (in a fit of anger, so I am told) along with a portrait of his father. Alice O'Connor, his old nanny, still hangs a portrait of his grandmother as a young girl and wearing a ball-dress, which he painted from a photograph: but this may date from after his return from Aran.

Edward was extremely meticulous about most things he did, in spite of his superficial bohemianism. His brother John says he showed this trait early in life, and it remained with him almost to the end. His working methods, when he had finally perfected and formulated them, were almost obsessively orderly and involved many stages which were plotted with a quasi-scientific precision. His love of theory and rules partly explains why he was drawn temperamentally to the workshop methods of the old Florentines. He read and re-read André Lhote's seminal books on modern art (which were a bible for several older Irish artists as well), Delacroix's *Journals*, Pissarro's letters, and he had also studied books on colour theory. He belonged, in fact, to the line of painter-scientists which stretches back to Leonardo, and even back to Graeco-Roman antiquity; two masters he particularly admired and had studied at first hand were Piero della Francesca and Seurat, both of them great theorists and pictorial thinkers. I do not know if he actually made use of the Golden Section and similar devices, but it is certain that nothing in his mature work was left to chance. Though he admired Francis Bacon enormously, he knew that he could never paint like him and did not aspire to do so; 'he's a gambler, he takes risks—that's a thing I could never do.'

The year on Aran, with few distractions or temptations except the local pub, was in fact his 'laboratory year'. He rented a small cottage near Kilmurvey, which still stands, and lived there very simply: he had little choice in this anyway since the cottage had no running water, or even the most elementary facilities. His food, too, seems to have been the very simplest. A great deal of his time was spent collecting the bones of dead sheep in the heather, and then studying or drawing them obsessively—particularly the skulls: he kept some of these to the end of his life. He was always fascinated by the way skin fitted over bone structure. Edward was drawn strongly to *nature morte*, in the most literal sense. All his life he preferred his animals dead and his birds stuffed, and he once said to me that he sometimes wished that the people he painted could be put into a 'fridge and taken out again when he needed them.

There were occasional visitors, including Patrick Pollen, who brought with him the painter Anne Madden (now the wife of Louis le Brocquy). She too was

interested in painting sheep bones, and there was an incident when she came across a sheep carcass which Edward claimed was his, setting off a violent argument. Another visitor was Vincent Koziell, who had mixed with Edward's bohemian set in London ('it was the greatest fun') and whose brother, Alex, was a friend of both Bacon and Freud. He came to stay in the cottage for two days, but ended by staying instead for ten, partly because of the weather. Edward was painting an evil-smelling dead crab, he remembers, but took time off to drive him round the island—or more accurately, since there was no cars, to hire a jaunting car to drive them around. It was drawn by a horse which Edward called Baby Power, and the jarvey was, he says, 'permanently pissed'. They spent a lot of time in the local bar, where they were ritually collected and driven home every night by the jarvey. He noticed how popular Edward was with all the locals, how they admired him, and how he identified with them in return. 'He had a wonderful sense of humour', Koziell says, and once he exercised it at the expense of a visiting German camera crew, whom he fed with tall stories and imaginary local lore. His old cottage is still there, and he is remembered locally after thirty-five years.

When he got back to Dublin and Newtown Park, Edward worked for a time in his studio over the harness-room, but he later moved to a studio in Parliament Street where a later occupant, David Hone, was disturbed by a 'terrible smell' and found that some dead birds Edward painted had been put out on the roof. (The painters Patrick Pye and Patrick Collins also seem to have worked there for periods.) Patrick Pollen was living in a flat in Leeson Street and told Edward that the bottom rooms were to let, so he moved in there. The bathroom facilities could only be reached via the hall, so Edward smashed a large hole in one wall, which gave him admission. A succeeding tenant says that this opening was not like a door, but was 'a couple of feet above the ground'.

Pollen, who later moved to America with his family and now lives in Salem, North Carolina, thinks he first met Edward in Davy Byrne's pub in 1950, 'when he was young and carefree'. He recalls affectionately and nostalgically his love for his craft and his obsession with technique, his capacity for solitary study, and his equal need for someone to talk to on occasions. Sometimes in the evening he would come upstairs when Pollen, who was working hard on stained-glass commissions for An Túr Gloine, was already in bed, and would talk for hours on end. Edward was already frequenting McDaids, the pub where Patrick Kavanagh held court, and sometimes after closing time he brought back his literary friends to Leeson Street, bottles and all. 'He had a tremendous wit, when he was in form', Pollen says, but he also noted Edward's highly-strung temperament which could erupt in sudden rages: 'he did go across the sound barrier at times.' A friend remembers him exploding suddenly during one of the Leeson Street parties,

at a horsey woman to whom he had sat listening in silence: 'I think you are the greatest ____ing bore I have ever met'! Some of their circle regarded him as essentially a dilettante ('he's a rich man's son, he doesn't have to work for a living'). Pollen himself thought there was something slightly schizophrenic about Edward's dual existence between Newtown Park, with its servants and large family cars, and the role of an ordinary Dubliner which he took up outside it.

Unlike Edward, Pollen did not do his creative work in Leeson Street; instead he shared a suburban studio with some other artists, including the sculptor Hilary Heron. Gradually the Leeson Street address generated its own bohemian folklore, and some of the parties there are still talked about, though most of the anecdotes are the merest pub mythology. Both men, in fact, were working hard—Pollen at his stained glass and Edward at his painting and on his colour dictionary, a project which cost him five years of research. Pollen noted his attraction for women: 'he had the pick of the bunch, if and when he wanted. It was just a question of how long it would last—he was in no position to marry.' This is born out by his sister and brother-in-law, Barbara and Richard Corballis, who had to cope with a succession of young, attractive women of various nationalities—'all nice girls too'—whom Edward had charmed and then fled from, usually giving them the Corballis's home address, where they turned up and were duly consoled.

Edward lived in Leeson Street for seven years, from 1959 to 1966. During this time he exhibited several works in group exhibitions—under his own name this time—and painted Patrick Kavanagh (pl. 2), whose poetry he admired, as well as obtaining his first legitimate commissions. One was for the portrait of Wanda Ryan (pl. 3), the child of close friends of his, and another was the portrait of Garech Browne (or de Brun), which marks a turning point in his career and was his first unquestionably major work (pl. 4). Garech Browne is the son of Lady Oranmore and Browne, one of the Guinness family and a famous society figure at the time (she now lives in retirement in Jersey). Browne was (and is) known for his patronage of Irish traditional music—he was a friend of the composer Seán Ó Riada and has been involved with various folk-music groups—and for his role in launching Claddagh Records. Yet another achievement was to paint the portrait of the actor Barry Fitzgerald, a legendary figure in the early days of the Abbey and later a successful film actor in Hollywood; this was finished in 1960, only a few months before Fitzgerald's death in Dublin. His handwritten letter of appreciation to the artist has survived and is warm and spontaneous, not merely the usual, conventional, thank-you note.

Anthony Cronin, the poet, critic, novelist and man of letters, had returned from London in 1963 and got to know Edward when he was working on the Garech portrait. He recalls that he had placed the Aran sweater and other acces-

sories on a wooden lay figure and spent 'months and months' painting it. Cronin also remembers the famous pressure cooker which Edward had got on account from Brown Thomas and cooked his meals in: 'he used to get beef and vegetables and put them all into the thing, and make a stew which would last him a week.' Once, when he had arranged to meet some visitors for lunch, he even took it into Davy Byrne's and cooked a meal there for them, apparently with the tacit permission of the bar staff.

Cronin, incidentally, knew Lucian Freud well in London and testifies that he never heard him mention Edward by name. He is certain, however, that Freud came regularly in the summer of 1951, or possibly 1952, to a studio which Patrick Swift had in Hatch Street. Is it possible that Edward had met Swift as early as this, and if so, did he encounter Freud there? Cronin recalls that Freud visited Luggala, the Co. Wicklow home of Lady Oranmore and Browne, about 1967, together with Lady Caroline Blackwood to whom he was married for a time. Garech Browne, who later lived in Luggala and still returns there periodically, thinks the same.

Edward's Polish friend Casimir Stamirski, who had known him in London, invited him to stay with him in Sardinia. He went, and stayed for two months, enjoying the island but not, according to Stamirski, painting very much. He remembers the date of this visit as 1963-64, but an entry in Edward's passport suggests 1965.

Edward McGuire Senior had since remarried, but Edward never struck up a sympathetic relationship with his stepmother, a Belgian by birth. In 1966 the father had bought a two-storey terrace house at 26 Sandycove Avenue West, Dun Laoghaire, which he now agreed to loan to his son for his lifetime. So Edward moved in that year and was to live there, with intermissions, until his death twenty years later. He had some skylights installed, to give a proper studio light, and worked away on the Garech portrait, which was finished in 1968 and shown in 1970 in the Royal Hibernian Academy's annual exhibition. It created a considerable stir there: I remember the excited circles around it at the opening of the exhibition, and the slow realisation that here was a new, original presence in Irish art. It was one of those rare pictures which equally impressed connoisseurs and the ordinary public, a masterpiece which was immediately recognised as such. After all the long, almost fallow years of study, preparation and solitude, Edward McGuire almost overnight had established himself as a painter of real quality.

YEARS OF FAME

As I MENTIONED in the first chapter, Edward was not only a Modernist, he was a Post-Modernist, though the term had not been coined at this time. His natural outlet, then, for showing his work, should have been the Living Art exhibitions, but from the late 1950s the IELA was in decline, and during the middle and late 1960s it became increasingly the vehicle of ambitious young art-school products leaping athletically on to the latest bandwagons, mostly imported second-hand from America or Britain (Paris was scarcely an influence any longer, and the new waves of German, Spanish and Italian art were barely beginning and were not known abroad). Edward's painting, whether still life or portraits, had no place there; in the eyes of such people, he was an old-style academic artist with a sur-real overlay. At least one rejection slip has survived, something which must have stung him badly, so from the late Sixties onwards Edward turned to the RHA and stayed with it until his death.

Since Edward's bird paintings (usually dead birds) hold such a central place in his output, it is timely here to trace how they began, or at least how he said they began (his memory in later years sometimes let him down, or rather it was occasionally touched with fantasy). When he was twenty, he met a Mr Williams who was taxidermist for the Natural History Museum in Dublin. It was a family tradition, and Mr Williams was by then eighty-five years old. He showed Edward various specimens he had stuffed and sold him three unmounted birds—an owl, a lapwing (plover) and a duck—for five shillings each, or twenty-five pence in today's money. He took them all home and had the owl mounted; they figure repeatedly in his work, and the originals remain in the Sandycove house today. In 1982 he wrote for *Image* magazine: 'OWL has been with me for thirty years. He is my favourite sitter, my friend. He has given me fifteen paintings, all of which I like. . . . He is the resolution of my dilemma, which is that of a por-trait painter. He was dead before I met him. And stuffed.'

By comparison, he painted very few landscapes, at least very few surviving ones. One, however, is a true, original masterpiece, perhaps the very finest pic-ture he ever did, and completed a year before the Garech portrait: it too was shown in the RHA where it also drew crowds around it (pl. 18). For him it is a large work (roughly 2½ feet by 4 feet) and it takes up a good deal of the wall

space where it hangs in the small flat of its owner, Eamonn McEnery, the friend who commissioned it. 'Rossenarra', the house depicted, belonged to his uncle, and he himself is one of the figures in the foreground, about to shoot—a skill he passed on to Edward, as I have already mentioned. McEnery's passion in life has been shooting, and he is now a bachelor in his middle fifties; he met Edward as early as 1955, he says, through Patrick Pollen—'my closest friend'. McEnery himself grew up in Rossenarra, in Co. Kilkenny, which was his grandfather's house and became his uncle's. He in turn was the son-in-law of Sir John Lavery, the noted painter of the *Belle Époque*, who died in 1941, marooned in Ireland by the war. Eamonn (pronounced roughly to rhyme with 'shaman') remembers about 250 Lavery paintings in the attic, on stretchers but without frames.

'We had a shooting lodge in Mayo, in Ballycroy, called Rock House. He [meaning Edward] used to stay there on and off from '58 to '61, for long periods, mainly on his own. In those days, it cost nothing to keep a place. There was a housekeeper, and so he just stayed. He was a very fine fellow, in lots of ways. I told him that a gun was a dangerous thing. We were only out an hour when I realised I had one of the finest natural shots I had ever met.' Patrick Pollen also mentions these periodic retreats—so typical of Edward—to the Mayo seaboard, where he would go to recover from the bohemian round in Dublin and return renewed. Pollen had his own bolt-hole: he used to take a boat to Lambay Island, off Dublin, and stay there with his maternal uncle, Lord Revelstoke.

'Rossenarra' cost Edward years of intensive work and was done in small brush-strokes, with every leaf and every stalk of grass depicted, but the effect is dreamlike rather than realistic—a 'memory' painting, like certain works of the Douanier Rousseau which it resembles. Later the house was occupied by the writer Richard Condon, who asked Edward to paint him a replica. The approach was made indirectly, through a painter friend, but nothing ever came of this. McEnery was angered by Edward's behaviour when painting a portrait of McEnery's father, and Eamonn—who had obtained the commission for him— says that he could never feel the same about him afterwards. He rarely saw him again after 1983, though he believes that at heart 'he was actually quite an innocent fellow', an insight which is entirely true. Obviously the friendship of this ultra-masculine, direct, outdoor-loving Irish-American meant a lot to Edward and did him much good. The remote shooting lodge, almost on the Atlantic and with wild wooded country around, was a splendid refuge from Dublin, and he also relished the jugged hare which the housekeeper cooked for the two young men.

Their friendship had another outcome, even another masterpiece. McEnery once gave Edward four snipe he had shot; instead of cooking and eating them, he took them back to Sandycove Avenue to paint. When he had finished the picture, according to his own account, he put the now-decaying snipe away in a

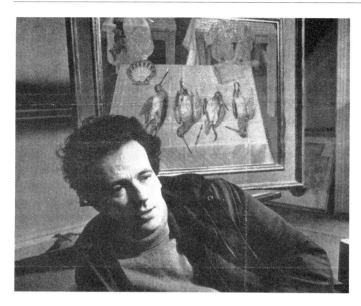

Newspaper photograph
of the artist at the time
of the exhibition
of 'Four Snipe', 1969

clothes cupboard and when he went later to get some dress clothes from there, he found them crawling with worms and partially eaten. (It makes a good story and it may well be true: it is probably half true, at least.) The painting, 'Four Snipe' (pl. 21), is a large one which shows McGuire in full maturity and command of his art—perfect placing, subtle distortions of space and perspective which probably escape the ordinary viewer, that curious sense of tension which he could suggest between inanimate objects. Yet regular clients of the Dawson Gallery in Dawson Street, run by Leo Smith, were intrigued to receive invitations to a one-man show which consisted of a single work (it opened on 24 November 1969, and ran for a week. The invitation was to 'a recent painting by Edward McGuire'). Smith is now dead and his gallery has vanished, but he was a shrewd and ultra-professional dealer and he realised that Edward, apart from his obvious social connections, was now a man who attracted attention of the right, discriminating kind. One newspaper interviewer suggested that the price (450 guineas) was high, to which Edward, plainly stung, retorted that he had seen a thousand pounds or more paid for rubbish. But the work was not sold, though shortly after it was bought by the woman who later became Edward's wife, Sara Browne.

Sara (Sally, as she is always called) says she first met Edward when she and her husband, Dominick Browne, called on him in Leeson Street where he was working on the portrait of Dominick's half-brother, Garech. Her maiden name was Wright[12] and she was the second of three daughters of a well-to-do dentist.

12 Edward, who had a snobbish streak, was fond of telling people, 'My wife is related to the O'Conor Don.' She is also related to the painter Roderic O'Conor (1860–1940).

There were no children of the marriage, but she and Dominick adopted an Indian girl—'a Mother Teresa of Calcutta child'—named Tresa, who is now married. For a while she and her husband lived part of the year in Mallorca; by the end of the Sixties they were virtually estranged and eventually she came to live with Edward at Sandycove in the spring of 1971. They did not get married until January 1974, after complicated divorce proceedings. The marriage took place quietly in a registry office in Chelsea and was witnessed by Sally's mother, Mrs Margaret West and by Edward's best man, Adrian Grant-Morris, with whom he had stayed the previous night. They and Adrian's son were the only people present at the wedding breakfast, and the McGuires returned almost immediately to Dublin.

Edward had previously avoided real amorous entanglements since the traumatic affair with Rita, though there was an interlude in 1969 when a socially ambitious Belgian girl had carried him off to the South of France—where, according to Sally, she tried to make Edward wear a yachting blazer and become one of the smart set at St Tropez. The role did not suit him, and he soon returned, carrying back with him the big 'Four Snipe' painting on which he was still working. There had also been a very brief but torrid affair with a dark beauty, the mistress of a friend, who turned up one weekend at Sandycove with bottles of champagne—an incident which cost him a valuable friendship, though the fault was not really his.[13]

His father gave them the Sandycove house as a wedding present, though they were a little alarmed when they discovered that this involved paying the remaining mortgage instalments themselves. They consulted John Jay, a Dublin solicitor well known for his good deeds to poets and artists and a man with a shrewd and resourceful mind. Jay wrote to McGuire Senior, who generously agreed to make the gift unconditional and to continue the payments himself. Sally says that it was virtually unfurnished and unheated, apart from Edward's stark studio: all he had was a bed, a table and chairs, and elementary cooking facilities. This changed slowly, but the couple still had little money and Edward's allowance was a small one—not unreasonably, since his family argued that he was by this stage an established painter, who could earn his own living. Brown Thomas was now a public company and Edward Senior had retired from it, leaving John to represent the family interest.

As I have said already, I only knew Edward really well in the last ten years of his life, but my impression was, and still is, that he was quite unsuited to domesticity. (This blunt statement may hurt or irritate some people, but I stick to it.) He could be happy alone for long periods, he enjoyed company when in the

13 The friend—who was much shorter—ritually slapped Edward across the face in a Dublin pub. He did not retaliate. In another age the two men would have fought a duel.

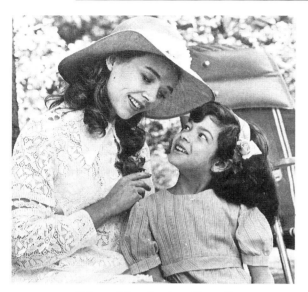

Sally and her daughter Tresa Browne
at the wedding of her sister, June 1969

The McGuire's cottage at Termon,
Mahery, Co. Donegal

mood, but when he married he was a bachelor of over forty who for years had rejected all the usual ties and demands, always going his own way insofar as he could afford to do so financially. He was a loner, even though he tried sporadically to escape his fate and his temperament. I do not doubt that he genuinely loved his wife, and vice versa; if he had not they would have parted after a few months, and Edward might have gone to Aran, or some equivalent, for yet another period of solitude. As a husband he made almost heroic efforts to suit himself to a role he was never meant to play, and for a long time it worked, but in the end he was going against the grain of his nature. I do not believe that any woman could have stayed with him indefinitely, nor he with her.

Before she went to live with him, Sally had bought a small cottage on the sea at Termon, Maghery, in Co. Donegal, near Dungloe. It was, she says, 'very primitive', with only a single tap, no sanitation or drainage, and only a single room. Edward fixed the roof and converted the loft into a studio, and there was a big window overlooking the sea. This became their summer home, and they spent months there every year, driving up from Dublin in a small grey van with a special rack for canvases. Edward did a lot of work there, and good work too, particularly on the portrait of the poet Michael Hartnett (pl. 7) which is one of his best works and was shown, like its immediate predecessors, at the annual RHA show.

The Hartnett portrait was begun at Sandycove, but while Edward was away in Donegal—incidentally, he was there collecting objects which he later painted in a still life called 'Lobsters' (pl. 23)—the portrait was vandalised by some

friends (?) who broke into his studio, including the dark beauty already mentioned. So it was taken to Donegal the next time he and Sally went there, tied to the rack on the mini-van's roof, and there at last it was finished. The remarkable portrait of Pearse Hutchinson also dates from about this period, and in 1974 came one of the highlights of Edward's career, the portrait of Seamus Heaney (pl. 12) which is probably still his best-known picture, reproduced many times and in all sorts of contexts. (This picture is in the Ulster Museum in Belfast, and I shall return to it later.)

Arguably, Edward was at the height of his powers as an artist in the years from 1968 to 1980: most of the works by which he will live were executed during that time. As he himself often said, his elaborate technique allowed him to paint about four pictures a year, no more; and if he tried to force the pace the quality almost certainly would have declined. He was never a man for whom paintings 'happened', never a man who could pick up a brush, make an almost random 'mark' on the canvas, and then pursue this to the point where the full, breathing, living organism of a picture stood there before his eyes. In some ways, he was a throwback to the days of Jan van Eyck. Yet even this slow rate of production gave the lie to his mockers who had said for years that he could never finish anything. In the words of John Ryan, painter, writer, editor and one-time owner of the Bailey bar and restaurant in which Edward had so often drunk: 'it used to take Edward four years to produce a painting, and now he produces four paintings a year.'

THE SEVENTIES

THE 1970s WERE EDWARD'S best years in terms of output, recognition, and personal stability—insofar as a man as complex and highly-strung as he was could ever be that. His wife was a considerable help in such matters as personal correspondence, commissions, financial matters: although he was meticulous, as has been said, he was also unbusinesslike, and inept in handling money and in certain other practical matters. The cottage in Donegal gave him the kind of bolthole which he always needed to get away from Dublin, and in 1972 he and Sally made a trip to Mallorca to stay with her sister Valerie and her husband, the French-Canadian writer Robert Goulet. Edward took to both of them and later painted Goulet's portrait.

The Royal Hibernian Academy and the Dawson Gallery continued to be his main outlets, though he had only become an associate member (ARHA) in 1973, and a full RHA in 1976. He grumbled often about the 'Royal Horse Artillery' (originally Seán O'Sullivan's quip) yet he was secretly rather proud to be elected, even if he claimed that most of his fellow-academicians were 'rentiers', architects, businessmen etc., and not full-time painters like himself. At the time of his election as ARHA, Maurice MacGonigal was President, and he had known Edward for many years and was also a friend of Edward's father: they served together on the Board of the National Gallery. According to his son Ciarán, he had always predicted a future for Edward who, he said, looked like 'the last of the Medicis'. David Hone, the portraitist who himself was PRHA for a time, says that MacGonigal wanted him to be elected a full RHA as soon as possible, but there was a delay for a year, whether through bureaucracy or internal opposition he does not say. Edward (very understandably) made some enemies inside the institution, and his relations with some later Presidents were notably strained.

David Hone says that Edward came to ordinary meetings of the RHA, but he does not remember him serving on the selection committee. 'He had no interest in schemes for raising money, or anything like that. But I think he basically liked being a member. Once he was elected, he could put in six or seven works at a time. After all, it was the only place you could show portraits in that way: no gallery would want them.'

In 1973 he was also commissioned to paint what has since become his most

Portrait of Robert Goulet,
Sally McGuire's brother-in-law, 1972

familiar picture, the portrait of Seamus Heaney (pl. 12). The commission came
from the Ulster Museum in Belfast through their Keeper of Paintings, Ted
Hickey, who offered a fee of £1,000, a good sum for the time. Edward first paid
a visit to Heaney's cottage in East Wicklow, where the two men sized each other
up and found each other sympathetic, and for the portrait itself, 'we did about
five or six sittings', Heaney says; 'it was not an enormous number, but it was
extremely concentrated.' As anybody will know who has seen the portrait,
Heaney sits at a table with his back to a window, gazing out at the viewer while
his hands rest on an open book; behind him, through the window, are the bird-
heads and laurel leaves[14] which he liked to add as a kind of imaginative, surreal
dimension—'his own kind of phantasmagoria', as Heaney says. The peculiarity
of this picture is that the poet is obviously seated on a chair, yet no part of the
chair is visible, either beneath the table or above it. Heaney admits that he was
'really cramped' in this pose, so that he felt 'hunched and really cornered'. When
the picture was completed, Edward 'stood it upside down to judge it—I liked
that— but I thought afterwards that there should have been part of the chair
between my legs.'

Heaney admits that originally he felt a little shy of Edward, 'especially since
he had been a friend of all these people, including Kavanagh: I felt a bit of an

14 In the RTE documentary shown in 1977, Edward says that these were enlarged privet
 leaves. They do not seem to be.

interloper.' Mutual friends warned him that Edward could be difficult and fractious, but he experienced none of this and found him warm and open, talking about Rembrandt—a favourite artist—and Pissarro's letters, one of his essential books. Heaney was rather surprised to find that he also greatly admired Goya, a painter who seemed temperamentally remote to Edward's interests.

In a letter dated 17 December 1990, to Sally McGuire enclosing his poem for this book, Seamus Heaney recalled:

> When Edward first came down to Glanmore Cottage to make arrangements for the portrait that Ted Hickey had commissioned, he took away the chestnuts of the title of the enclosed [poem]. We thought they might be a kind of significant prop or fetish somewhere in the picture, but in the event, the picture triumphed without them. But they did gleam and shine in my memory and somehow the fullness and richness and new-shelled, pristine quality of the first excitements of meeting Edward and beginning a picture got involved with the image.

Instead of the usual RHA setting, this picture was first seen in Dublin at the Oireachtas Exhibition of 1975 and made an immediate impression which it has never failed to make since.[15] Meanwhile Edward was now appearing in exhibitions abroad, including the 'Irish Imagination' which originally formed part of the 1971 Rosc Exhibition in Dublin, and shortly after travelled to America. Reviews were very mixed, but several critics singled him out, even when they disliked the exhibition as a whole; Paul Richard of the *Washington Post* found it 'distressingly provincial' but chose the work of Edward, William Scott and Louis le Brocquy as exceptions to this (the Hartnett portrait, incidentally, was included, and was sold to an American buyer).

In 1974 he was included in an international exhibition at Cagnes-sur-Mer, in the South of France, where he was awarded a prize. In 1976 he was awarded the Douglas Hyde Gold Medal at the Annual Oireachtas Exhibition, and in 1978 the Martin Toonder Award for Visual Arts, which carried a prize of £2,500. At the end of the decade, in 1980, he was one of the artists chosen for a London exhibition called 'The Delighted Eye', part of a festival called a 'A Taste of Ireland' which was intended to demonstrate to England the breadth of contemporary Irish culture. For this his Heaney portrait was chosen, and as always, it made a powerful, hypnotic effect on virtually all visitors and viewers.

McGuire's work was also creeping almost inexorably into public collections. The Ulster Museum had been a pioneer in this field, but in 1975 the Dublin Municipal (now Hugh Lane) Gallery of Modern Art acquired his portrait (pl. 15)

15 There was a festive 'unveiling' at the Ulster Museum in June 1974.

of the senior novelist, Francis Stuart. This had been completed the year before, but Stuart either did not wish to buy it, or—which may be more likely—could not afford to do so, as so often happened with the writers whom Edward painted. It hung in the Dawson Gallery, where neither Edward nor Leo Smith believed it would find a buyer, but a Dublin doctor proved them wrong by buying it for £1,150, and he resold it to the Municipal Gallery for the same price. Edward remarked that Stuart had 'a great face, great bone structure—a painter's delight'. And a smaller portrait of Heaney, showing only the poet's head, eventually was bought by the National Gallery. Private buyers, too, now sought him out and his still-life and bird paintings were becoming collector's pieces.

In 1973 the Ulster Museum, always a good friend to him, had included Edward along with Deborah Brown, Tim Goulding, Cecil King, Neil Shawcross and Patrick Scott, in a complex exhibition called 'Artist's Choice'.[16] This was an imaginative attempt to recreate the immediate environment of a painter's work, his tools, studio 'props' and the like, enhanced by blown-up photographs as well as examples of his finished work. The exhibition was reviewed for the *Irish Times* by the elder Northern poet and respected art critic, John Hewitt, who wrote about the section devoted to Edward: 'on the shelves at the back, the actual lobsters, the sea-shells, the horn, the animal skull refer immediately to the canvases; the battered lay figure,[17] slouched on the chair, the paint-box and the shade-cards establish the laboratory nature of his soul.' That 'laboratory' atmosphere can be vouched for by anyone who sat there. The Hartnett, Garech Browne, and Pearse Hutchinson (pl. 6) portraits were all shown, as well as some still-life pieces, a small self-portrait, and the painting of Patrick Kavanagh.

The exhibition survives now only in photographs or in memory, but a more durable record of him at work, and in conversation, is contained in the documentary shown on Radio Telefís Éireann on 6 December 1977, directed and edited by Ted Dolan. Good interviews with Edward survive in print, which capture his opinions and his working philosophy, but this is an unique record which shows him in his studio at work, and preserves the sound of his voice with its cultured, very individual and rather public-school intonation. A number of his best-known portraits were shown, including those of Heaney, Hartnett, and Francis Stuart, the 'Four Snipe' (pl. 21) and some owl pictures. The portrait of Anthony Cronin, who appears in the film, was then in an unfinished state. For anyone wishing to study Edward and his art, this TV picture is essential viewing.

The gradual emergence from a coterie reputation into a more general recognition certainly gave him the kind of encouragement which he needed, and

16 The initial idea was Harriet Cooke's. The estranged wife of the painter Barrie Cooke, she was American by birth and worked as a journalist and critic in Dublin.
17 The lay figure was acquired in Italy.

Portrait of Cearbhall Ó Dálaigh, 1976

which he lacked earlier in his career. Yet it had its negative side too, including the fact that Edward was now established in the eyes of the fashion-snobs as a glamour portrait painter—which is surely the last thing he ever wanted to be. He had always despised professional flatterers of the Annigoni type (even if he had, very briefly, been an Annigoni student in Rome) and as he often pointed out, his portraits of writers were self-chosen and not commissions (though in some cases, of course, they were that as well). But now he began to get commissions to paint leading academics, politicians, even society women; and though he turned many of these down, he admitted that he accepted others purely out of the necessity to earn a living. Edward's very slow working methods (to labour a point already made) meant that his normal rate of production was about four paintings a year, or six at the most—that is to say, six large-scale pieces, not allowing for the occasional heads and the small bird pictures which he also produced. Though his prices were, by Irish standards, reasonably high, his earning power was still strictly limited. The American artist Andrew Wyeth, whose style has a good deal in common with Edward but who works in tempera rather than in oil,[18] is also a notoriously slow and obsessive worker, but this is compensated by the fact that he is one of the world's highest-paid artists. To be free of financial problems, Edward needed either a sizeable private income, or an exceptionally high price range. He had neither.

The result of this was that he was often forced to live on advances from Leo Smith or, after Smith's rather sudden death in 1977, from his successor, John

18 I once asked Edward why he did not work in tempera, to which he seemed suited. He answered that he had tried it, but did not like it.

Taylor of the Taylor Galleries. When Smith did sell a picture for him—and they were rarely hard to sell—the price was usually offset by advances, the gallery's commission, framing costs etc. Edward and Sally lived very simply, yet even their relatively spartan life style needed a higher income to support it. Later, in the 1980s, when Edward was a member of Aosdána (the state institution set up for artists and writers, largely through the initiative of Charlie Haughey),[19] he was able to apply for and get the £6000-a-year 'Cnuas' for which members were eligible, if they had no other source of income besides their art. Unfortunately, this relief came too late.

Edward was a complex person, in some respects a natural-born bohemian, who could have lived happily on the Left Bank in Paris in the old days and painted in a garret; but in other ways, a man of his background and class, who took a pride in his professional ability and felt he should earn his own living. The blood of his business ancestors was in his veins, even if he sometimes abused them, and public recognition was important even if his higher self despised it. He did not stoop to mere potboilers and even when a sitter did not greatly interest him, he produced a highly skilled piece of professional picture-making. I certainly do not believe that he regarded the portraits of such eminent academics as Professor Jessop of Trinity College (pl. 9), or the President of the University College, Cork, Dr McCarthy, as mere routine chores. The result, in each case, is much too good for that. Similarly, his portraits of leading politicians such as Charles Haughey, Liam Cosgrave and President Ó Dálaigh are all solid and well-finished works. He later said that Ó Dálaigh was 'a saint', while Haughey became a personal friend and well-wisher.

Nevertheless, all this verged on 'official' portraiture, and Edward was a private man whose great gift was to express a basically poetic, personal interpretation of people under the mask of glassy objectivity and impersonality. Portraits apart, there should be far more landscapes by him in existence, and more too of his strange, questioning still lives. Once again, he was in a role to which he was not entirely suited, and the efforts it cost took toll of his nervous stamina and brought out a vein of petulance and irritability which sometimes led to outbursts and scenes. There was one occasion when a very prominent politician had made an appointment for a sitting, for which Edward waited in Sandycove Avenue, but the sitter did not turn up. When Edward rang up the relevant government department, he was told that Mr So-and-so was 'a very busy man'—precisely the kind of answer guaranteed to make him feel insulted and demeaned. According to a friend, he rang up the politician himself shortly after and (probably lubricated by several bottles of stout) called him a 'two-bit punk' and other choice terms. It is to the credit of the politician that he wrote a very handsome letter of apology and never bore Edward any grudge. The portrait was duly painted.

19 Anthony Cronin was a leading proponent of this scheme.

THE EIGHTIES AND DECLINE

EDWARD'S FRIENDS WERE generally not only loyal to him in good and bad times, but actively solicitous. Sometimes, when a portrait was not sold (that is to say, when the sitter either did not like it or could not afford to pay for it) they rallied round in various ways. Allan Bell, who had known him from early McDaid's days, helped to enlist John and Harden Jay to buy the Pearse Hutchinson portrait (he could not afford it himself; pl. 6). James White, for many years Director of the National Gallery and an old friend of Edward's father, discreetly helped to get him suitable commissions. Patrick MacEntee, the eminent lawyer, bought various portraits (including my own) not all of which he can have coveted to own.

One of the most vexatious of all commissions came from Sir Alfred Beit and his wife Clementine, and was finally completed in 1979 after years of mutual frustration. The Beits had in mind a Gainsborough-style, outdoors, country-gentlemen picture with their house, Russborough, in the background; Edward, who liked to pose his sitters in his own way and even to alter their dress as he saw fit, found this tied him down too much. There were endless letters and delays, until at one stage Sir Alfred Beit wrote to Edward saying that since he had not heard from him for a long time, he regarded the commission as cancelled. Diplomacy brought them together again, but the finished painting was stilted and untypical and, I suspect, a tongue-in-check parody of the 'stately home' convention.[20] Another commission with a touch of farce was the one to paint Sir William Whitelaw, the Tory politician and former Secretary for Northern Ireland—an idea triggered off when Whitelaw's son-in-law, Robert Thomas, saw a reproduction of the Heaney portrait. Since Whitelaw, for obvious security reasons, could not come to the Republic, Edward travelled up to his house in the North of England and was simultaneously annoyed and irritated when he found his luggage had apparently been searched (a very necessary precaution, in fact, which was done for his own safety as much as for Whitelaw's).[21] I have not seen this painting, but to judge from a reproduction it is competent

20 When Beit gave part of his collection of pictures to the nation, Edward reduced his own fee by £1000—a large gesture for a man short of money.
21 The Blimpishness of the entire Whitelaw ambience gave Edward a lot of exasperated amusement. He told anecdotes about it to the end of his life which I shall not print here.

Portrait of Sir Alfred Beit and his wife Clementine, 1979

though uninspired. (The owner is Whitelaw's daughter, Mrs Carol Thomas.) It was completed in 1979 and was submitted for exhibition at the annual Royal Academy show in London; when it was rejected Edward appealed to David Hone, who told him that he could do nothing about the matter. The initiative seems to have came from the Whitelaw family, who apparently did not realise that only British nationals or residents were eligible as exhibitors.

In 1978 he had painted a portrait of Charles Haughey, and Haughey commissioned another, this time a large-scale, formal, equestrian portrait showing the Fianna Fáil leader in hunting dress with his country house at Kinsealy, Co. Dublin, in the background—in short, as a country squire. By this time Edward and Sally had sold the Donegal cottage and with the money bought a small farm building at Ballinaclash, in Co. Wicklow, near Rathdrum. It was there that Edward did most of the work on this large picture, which has not been seen in public; Haughey himself came down to visit them and on at least one occasion his favourite wolfhound was delivered by car, so that Edward might paint her.

By late 1981, he and Sally were leading virtually separate lives, she in Ballinaclash and he in Sandycove, though they met at regular intervals and talked regularly over the telephone. I do not propose holding an inquest on their marriage, but Edward's drinking habits undoubtedly had a lot to do with it, and Sally often had been forced to drive in from Sandycove late at night to some downtown Dublin pub, after Edward had rung imperiously for her to collect

him. He was always, she says, 'very affectionate' and was devoted to her adopted daughter, but her nervous stamina began to suffer: in no way was she a bohemian, and Dublin pub life frightened and repelled her. Edward had drunk hard since his early twenties (though possibly not in Italy) but this was now reaching the danger limit, and in any case, at fifty or over a man cannot drink as he did in the past. (He must have realised this himself, since he went 'on the dry' for six months in 1980-81.) I never saw him drink spirits, though he would accept a whiskey if given one, and curiously enough he had little interest in wine. His tipple was bottled Guinness, particularly large bottles, and he always had a supply on hand. Neither was he a noisy, demonstrative drinker; he quietly 'topped up', though at a certain stage he might fly into one of his rages or—this happened increasingly towards the end of his life—launch into long, obsessive diatribes against his enemies and false friends. At that stage, it was best to leave as quietly and tactfully as possible, since the experience was a very depressing one, especially to anybody who knew Edward's gifts, the clarity of his mind when sober, and the inherent fineness of his character. He himself realised fully that he had already begun to alienate people, and this increased his inner melancholia and self-dissatisfaction.

He took the apparent failure of his marriage hard, but psychologically the cracks had begun to appear before that and were, in fact, as much the cause as the effect. Why was Edward McGuire, in his last six years or so of life, so unhappy and at odds with both the world and himself? Financial stress undoubtedly had something to do with it, but this might have been solved and in fact was solved, thanks to Aosdána. There was also the fact that he had begun to accept too many commissions, some of them inherently boring, and he himself said that he wanted to get back to painting landscape and still life. (He did, in any case, paint a number of Owl pictures in his last years, some of them highly impressive, though the craftsmanship coarsened towards the end.) The passing of youth, with its resilience and capacity for optimism, was another factor, particularly since Edward had been a golden youth and was now an ageing artist fighting against debt and loneliness. And in spite of the fact that many good judges recognised his gifts, he bitterly resented being regarded as no more than an overworked professional portraitist while men (and women) with not a quarter of his talent were praised as heroes of the *avant-garde*, and logrolled into prestige international exhibitions and catalogues. But these reasons are all relatively external; his real divisions probably were inner ones, which his friends guessed at but could not reach. In spite of his outward outspokenness, he had a core of inner reticence and privacy which was sealed in iron.

Meanwhile there was another one-man show, only the second of his career, at the Taylor Galleries in December 1983. This included some of the Owl paintings,

Portrait of Sir William Whitelaw, 1979

a portrait of the senior (and greatly respected) painter Patrick Collins—a near neighbour, whom Edward often met for a drink—and two of the Northern poet Michael Longley, whom Edward liked as much as Longley seems to have liked him in return (pl. 16). There was also a number of bird pictures of choughs—an unusual subject. Another valued friendship was with the poet Paul Durcan (pl. 14), whom he painted and who had recently emerged from a traumatic marriage break-up. They corresponded—or at least Durcan wrote often to Edward, who was notoriously sluggish at writing replies. Durcan recalls: 'he wrote me a very moving letter when he had finished it [the portrait]. When he really got going, he would talk about Pissarro or van Gogh as though they were in the room, as though they had confided in him personally.' One of the last times they met was on a train which Edward had boarded at Rathdrum, on his way back to Dublin after visiting Sally in Ballinaclash. Durcan says that he was carrying a large canvas bag and was in 'the best of form', talking animatedly and totally relaxed. At Bray Station Edward got off and Durcan vividly remembers the debonair way in which he stepped out on to the platform and waved goodbye, before his tall, erect figure vanished out of sight.

A variety of artists lived in the Dun Laoghaire area, but though most of them liked and respected him, several were wary of his mercurial changes of mood and the way in which he might suddenly turn to invective of his enemies or even—as sometimes happened—into outright quarrelling. Charles Brady, an American painter who lived (and still does) in the area, had always respected Edward's talent and sheer professional discipline, yet eventually grew nervous of meeting

The McGuire's cottage
at Ballinaclash,
Co. Wicklow

Edward and Sally McGuire
at Ballinaclash

him regularly in the local pubs. The sculptor, Melanie le Brocquy, drove him home one night and was told that her family were 'bloody bourgeois', a favourite taunt when Edward was in his cups. 'Well,' she replied tartly, 'and what about yours?' Another sculptor, Imogen Stuart, lived only two doors away, and when Edward called in she would give him coffee, but not alcohol. One evening, as they sat looking at television, she noticed that he was groping under his chair, and civilly asked why. He announced that he was searching for his glass. 'But Edward, you didn't have a glass!' Imogen refused to take the hint, and instead made him another cup of coffee. She also recalls how inspired and inspiring a talker he could be on art and artists, though he was 'not a good listener'. He also called very often on the elder actress Shelagh Richards, who lived across the road and remained his confidante until her death.

Edward was innately courteous, at time even formal, never a man who rejoiced in gratuitous rudeness or who thought, in his sober moments, that there was any special merit in shocking people. All his life he had found it hard to swallow his opinions; and since he was much more intelligent than most of those around him and saw through people, and indeed entire circles and cliques, with an impersonal clarity, his frank speaking occasionally earned him hatred. He openly despised a great deal of the Dublin art world, and had little respect for reputations, either among conservative artists or the self-styled *avant-garde*. In his last

64

years, however, this contributed to a paranoiac strain which sometimes made him attack friends as well as enemies—sometimes, indeed, friends rather than enemies. I never quarrelled with him myself, though there was a period in which I avoided him and indeed almost broke with him completely. The circumstances were these: I had tried to persuade a certain public gallery in Dublin to mount a retrospective exhibition of his work and had promised to help in any way I could. Edward got wind of this and, without my knowledge, enlisted some female socialites who were friends of his; their well-meant but elephantine intervention killed whatever chances there were of the exhibition taking place. But since he had suffered mentally much more than I had from all this, I said nothing to him and let the thing pass. I suspect, however, that the whole episode added slightly to his incipient sense of rejection and failure.

John Taylor of the Taylor Galleries was periodically under siege from Edward on the telephone, describing some 'marvellous picture' which he was working on, or had nearly finished or had just begun, and asking for an advance on it. Some were actually begun or even completed, but others never existed outside his imagination. Telephone calls from Edward, in fact, became part of life and I myself got a great many about this time, some of them at about half-past-one in the morning.[22] Plainly, he was wretchedly lonely at times and I could picture him sitting melancholically at home; so even passive listening for half an hour was a small price to pay if it cheered him up. Sometimes he would denounce somebody as 'an awful shit' and then ring up a few days later and say that he had been all wrong about *so-and-so*, who was 'a marvellous fellow'.

Looking back, I detect a factor which at the time never occurred to me—that at heart he was bored with Dublin, its limited horizons and provincial pretences, and that he needed a change to Italy or Paris, or even New York. But since he was now a man over fifty, had he left it too late to make a reputation outside Ireland, or to follow up the ripples of interest his work had raised on the rare occasions when it was seen abroad? I was a guest of his at a dinner in a south Dublin hotel at which a London dealer whom he knew was present, with his wife; friendly parties had brought them together that evening, in the hope that he would offer Edward an exhibition. For a time the evening went very well, but then at a certain stage he threw one of his outsize scenes, insulting his visitors and storming off without paying the bill (which was quite sizeable and was paid by a friend of mine).

Yet in 1984 Edward got through a good volume of work, including two portraits of his old friend Julia O'Faoláin and some impressive, heraldic paintings of his favourite owls. It was in this year, too, that he painted one of his rare

22 A practising psychiatrist tells me that this is the classic hour in which depression, and/or feelings of failure and rejection, sets in.

Portrait of
Patrick Collins, 1983

'Owl', 1983

'Asters', 1984

flower-pieces, 'Asters', owned by his friend Allan Bell, whom he often visited in the evenings. From then on his rate of production began to slow down and a number of portraits were never to be finished, including one of Maurice Craig, the architectural historian. He also lost some commissions by negligence, deliberate or otherwise; in 1984, Bord na Mona (the Irish Turf Board) was forced to cancel a commission for a painting 'because of undue delay'. There were long delays in painting the Northern Nationalist politician, John Hume, though the portrait was near completion when he died.

Through 1985, his physical condition was obviously deteriorating—at times his face had a strange bluish tint which was noticed by others besides myself, and Ciarán MacGonigal recalled to me recently how Edward's patrician head took on an almost gaunt look. Under the woollen skull-cap he habitually wore, his long, distinguished face looked increasingly pinched and world-weary, yet he walked as erect as ever and when he was fully himself was the old Edward we knew.

Late in the autumn of 1986 there was a brawl in the house of a mutual acquaintance between Edward and another painter, who had asked Edward to

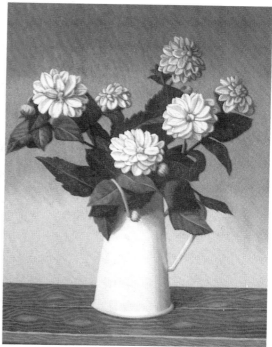

join him in the house of the woman concerned but seemingly objected to him bringing other people along. Though Edward was a tall man (six-foot-one) and still muscular, he was knocked down, and the other painter—whom I have known for many years, and who genuinely admired Edward's work—later expressed his remorse to me about the episode. I am told, however, that it had nothing to do medically with what followed a few days later; on 12 November, Edward suffered a severe heart attack and was taken to St Michael's Hospital in Dun Laoghaire.

At first his case did not seem desperate, but shortly afterwards he was put into intensive care, then moved by special ambulance to St Vincent's Hospital some miles away. Like many other friends of his, I was given the impression that he was on the mend, and though he saw very few visitors, I wrote a 'get-well' postcard, a Picasso reproduction I had recently bought in London. The card was never posted (I still have it) because Edward was now lying inside a glassed-in cubicle, while doctors fought to keep him alive. (Sally, who stayed with him, says that he was given a temporary pacemaker). He died on 26 November, and his death certificate, dated 17 December 1986, lists the cause of his death as 'cardiac arrest—myocardial infarction.' According to Sebastian Ryan, his aesthetic fastidiousness stayed with him to the end; at one stage he quietly asked that a commercial Italian print on the wall of his hospital room should be turned inwards.

Edward and Sally, Ballinclash, Christmas 1985

The Studio at Sandycove, November 1986

His funeral, to Dean's Grange Cemetery, was of course a crowded one and his father, now in his eighties, stood erect by the graveside, while some other members of his family wept openly. Sally, though shattered, insisted on being present and stood beside the officiating priest. Artists, socialites, literary men, politicians, journalists, lawyers, businessmen were all present to pay their last respects. Among the entire Dublin intelligentsia—writers, painters, critics, historians—there was a pervading sense that something unique had gone from the country's cultural life.

STANDING

IT MUST REMAIN an unanswerable question as to how far Edward McGuire had fulfilled his potential at his death, or his ultimate ambitions as an artist. If he had lived another ten or fifteen years, would his work have got better or worse, or would it have taken off in some unforeseeable direction? My own guess is that the last possibility is the most likely one. The inner self-dissatisfaction so evident in the 1980s should have been a prelude to a new creative phase, in which he might well have abandoned portraiture completely and have taken the bird pictures, his still life and landscape interests into a territory which he could so far only glimpse vaguely. Such cases are not rare in art history—Sargent, for instance, who gave up painting 'mugs' at the apex of his fame.

Even allowing for his relatively short life and limited output, his place in Irish painting seems sure, and is likely to grow rather than diminish. Time will sort out the finest and most characteristic of his pictures from the not-so-good, those works into which he really put his inner self from the ones into which he merely put professional industry. To some extent, this process is happening already; it was even happening in his lifetime. The commissioned portraits of politicians, and most of the 'society' ones of the Eighties, are clearly inferior to such key paintings as the Heaney, Garech Browne, Pearse Hutchinson, and Monk Gibbon portraits, or certain pictures of children, or the still-life masterpieces such as 'Four Snipe' (pl. 21), or 'The Window' (1974; pl. 20). Without a certain inner freedom, Edward's imagination tended to wilt, leaving only the outer mannerisms of his style without the inner necessity which made that style so individual.

Psychologically, he was a man of the 1950s, a decade which is oddly difficult to pinpoint intellectually for those who did not live through it. The Sixties, by contrast, is easy to pin down, in terms of flavour and key personalities: it was the age of the Beatles and Pop Art, Hockney and Warhol, sexual liberation and the Hippies, an age of relative affluence and self-indulgent 'protest' in which youth enjoyed its fling after the decade of the Cold War and the nightmare of the real war immediately before that. But the Fifties seem more shadowy, a decade of greys and half-lights. Its most typical writer was probably Beckett, whose play *Waiting for Godot* became within a very short space of time what Eliot's *The Waste Land* had been for the preceding generation, or Strindberg's

plays had been a generation earlier again. In *Godot* the epoch saw its own face, in a way it did not do so in the work of any contemporary novelist or poet.

In America, which had escaped wartime devastation and disillusionment, the Fifties saw a great outburst of abstract art on a heroic scale, uninhibited and vibrant with energy. Apart from the Cobra painters and a few isolated individuals, European art had no real equivalent. The abstract art of Wols, for instance, is small-scale and anguished, and in Britain the painting of Bacon, Freud and lesser figures such as the 'two Roberts' or Graham Sutherland, is uneasy or introspective, sometimes ridden by fear or tensions, and generally rather bare and austere. Certainly, it is not in the great French tradition of *belle peinture*, even though most of these artists looked towards Paris. In Ireland, Louis le Brocquy is an obvious parallel. Plainly, this was not an art which came out of an age of material (or materialist) well being, like the *Belle Époque*. Europe had slowly emerged out of a waking nightmare to find the world frozen into two vast hostile camps, under the constant threat of nuclear destruction, and with food, fuel and other essential commodities severely rationed. The new Europe of the EC was as yet barely in embryo.

The immediate post-war age has been called the Age of Austerity. So it was, but it could also claim to be, like the 1930s, an Age of Anxiety. And though the arts revived with astonishing speed, the financial rewards for writers and artists were nothing like what they are today, except for a few august exceptions such as Picasso. Ireland, in particular, lacked either the type of monied private buyer who has been the mainstay of American art, or the kind of state patronage and support which has become the norm in today's welfare states. In Dublin, artistic life was a semi-underground affair, typified by the Catacombs, by seedy pubs such as McDaid's, and the basement flats of its run-down bohemia. A great deal of it was private and introspective, without much expectation of reward or public interest, and Edward was a typical figure of his era in this respect, though he took it to extremes which few others did, or would have been capable of doing. At this point, someone may well interject that at least, unlike nearly all his contemporaries, he had some private means. That is true, even if his family allowance was a small one, but against that his working methods were abnormally slow and cerebral. And who, other than he, would have spent whole years of their lives working in solitude on such a project as a colour dictionary?

I have already mentioned that he had the kind of artist-scientist's intellect which was a feature of the Renaissance, and that his devotion to his craft was absolute; but in the end, Edward would never have been satisfied either by pictorial science or mere mastery of his medium technically. Anybody who knew him well—and I do not mean only socially, I mean people who knew or guessed at his inner life—realised that he had the quasi-religious sense of the artist's calling

70

which was shared by van Gogh, Delacroix and Cézanne, to mention three outstanding examples. There was no 'romantic' self-glorification involved, in fact it meant the subjugation of the self to the artistic vocation. Edward was a monk of his art, however much he may at times have seemed exactly the opposite of this. He had the true ascetic's need for withdrawal and contemplation, which made him live for weeks on end in his studio like a monk in his cell. The various poetasters, bohemians and hangers-on who drank with him in McDaid's or The Bailey may have thought that they knew the real man, but the Edward McGuire who talked volubly with a glass of Guinness in his hand, or who drew sketches on beer-mats and the like, was only the outward shell. The real man was the recluse who holed up in Leeson Street or Sandycove, or in his Donegal cottage, or in Eamonn McEnery's shooting lodge in Mayo, or in his cottage in Aran, painting, theorising and formulating.

Edward told several of his interviewers (and repeated it too on Ted Dolan's RTE documentary) that anybody could be a painter if they were prepared to learn the craft, study nature and the museums, and spend long hours alone at work. Can he really have believed this? The annals of art are full of men who did just that, but whose work is forgotten: whatever Carlyle may have said, a capacity for taking pains will not make a man of genius unless genius is innate in him, otherwise it is only a recipe for industrious mediocrity. It cost Edward terrible labour pains to realise his vision in paint, but the vision was there.

Curiously, what rarely emerges from any of Edward's interviews and *obiter dicta* is his own considerable erudition, which again had been acquired by solitary, uncountable hours in museums and art galleries. Ciarán MacGonigal remembers having a long conversation with him about Pope Pius II (Piccolomini) and discovered in doing so that Edward had a strong sense of history: they also shared a common interest in the lives of the Medici and the daily round of Florentine life at the time of the Renaissance. Since Ciarán is a professional art historian, who had studied officially in Italy, this gives an indication of the knowledge and insight Edward possessed in the areas which genuinely interested him. My own belief is that he had not only closely studied the Renaissance masters but the Mannerists such as Pontormo and Bronzino, and perhaps even eclectics such as Andrea del Sarto. One element which always fascinated him in Old Master portraiture was the clothes and accessories, and since he could not find sitters dressed in silk, satin, velvet or ermine, he often painted in clothing afterwards as it suited him. He told Anthony Cronin that he had painted him in his cap because he liked the way in which Rembrandt painted his sitters wearing hats, which gave a special shadowed look to the faces. (In my own portrait, I am shown wearing a striped jacket of a kind I never owned.)

What must remain, at best, informed speculation is to what extent the 'props'

and accessories in his portraits were purely formal devices, or whether they also have some symbolic or emblematic content. Obviously Wanda Ryan with her doll (pl. 3), Monk Gibbon with his cat, Professor Jessop of Trinity with his mortarboard on his head and a book in his hands (pl. 9), John Ryan with a copy of the magazine *Envoy* (pl. 5), offer no iconic problems: the accessories are simply an extension of the sitters, part of their outward identity. But in the Michael Hartnett portrait (pl. 7), for instance, the solitary lapwing in a window pane suggests an extra, symbolical (though not 'literary') dimension, even though Edward claimed that he did not know when he painted it that lapwings (plover) occur in Hartnett's poetry. In many of the portraits and large still lives, there is a kind of dreamlike juxtaposition of objects which is close to di Chirico and to Magritte. In all but the most conventional portraits he painted, he tried to lift the picture out of any banal or purely realistic context and give it an aura of unreality and mystery. Edward, emphatically, was a poetic painter, not a prose one, and in large formal 'society' portraiture, like that of the Beits, he was forced into conventions which he hated.

Without doubt, his sense of abstract form and design was one of his strongest qualities combined with his hard-won skill at placing the human figure in space. The early portraits, including the Garech Browne and Hutchinson pictures, are mostly full length, but later he usually preferred to paint people in half or three-quarter length. The frontal stances scarcely even alter, giving the sitters that fixed, slightly hypnotised (and hypnotic) look which is so characteristic. He even treats his owls in this way, so that they fix you with an uncanny regard, as though about to pounce or swoop upon the viewer or to deliver some oracular message (the owl, of course, has a special role in folklore and mythology for its solitariness, for oracular wisdom, and for nocturnal inspiration as the bird of Pallas). Clearly, the subject meant something very special to Edward, who himself was so private and studious, so much of a night bird at times, and well versed in the more esoteric lore and traditions of paintings. Did these owls, even semi-consciously, come to have a kind of symbolic value as his own oracular birds, the artist's messengers from the 'other' side of things? Did he remember the owl perched by Michelangelo's 'Night' on the Medici tombs, for instance? Edward was not a symbolist, but between symbols and images the line can be very tenuous, and images such as the owl carry their own inherent symbolism.

STYLE AND WORKING METHODS

To PLACE EDWARD in the context of Irish art is difficult, and perhaps even irrelevant; he was *sui generis* and stood quite apart, as I have said, from the Orpen tradition which was still strong when he began painting. His debt to Lucian Freud has been stressed, but the debt to Patrick Swift is less known, though Edward told Harriet Cooke in an interview for the *Irish Times* (17 April 1973): 'Patrick Swift was instrumental in my starting to paint; Patrick Swift and Lucian Freud, they were both people I was in sympathy with.' Swift, of course, was influenced by Freud, but he was a more independent personality than is realised today, and there is an introspective, self-questioning aura about his portraits and self-portraits which is very different from Freud's edgy, more aggressive style.

Edward also proclaimed his admiration for Patrick Tuohy, perhaps the most gifted of all the Orpen pupils, and the most untypical. This affinity can be seen most clearly when he paints children and certain women, and infuses the sitters with that kind of inward, poetic quality which the Germans call *Innigkeit*. Tuohy, of course, was a romantic colourist, while Edward was a 'tonalist', denying himself many of the resources of colour because they did not serve his purpose. But though he used very thin paint, and his work as a whole lacks sensuous appeal, it is utterly mistaken to regard Edward as basically a draughtsman who added colour to an essentially linear vision. That is to misinterpret all that he aimed at, and what at his best he achieved.

Few drawings of his have survived, and no sketchbooks; those that have, are rarely remarkable. The writer Brian Lynch, whose portrait Edward began but never finished, remembers him producing drawing after drawing, numbered in sequence, 1, 2, 3, 4, 5, etc., all part of his tonal sequence, and these he later destroyed. He was genuinely surprised when Lynch suggested that he should keep them, and perhaps even sell them. Lynch also remembers that with the actual painting he worked 'from green up', which is borne out by the various unfinished pictures left after his death (Lynch's own one has not survived). The idea that Edward first realised his intention with a fully modelled drawing as a foundation, is not true; the drawing was often the merest outline, little more than a map. It was through his slow, patient, building up of tonal gradations, done over months and with very thin paint, which enabled him to present that

complete, breathing image. He told Harriet Cooke; 'I'm not a genius, and when I get my results they have to be got in a very painful manner.' Looking back, I wonder if he had been influenced in this by William Coldstream, whose work he would have seen in London and who was also an influential teacher at the Slade. Coldstream's portraits are also built up with great slowness by repeated layers of paint no thicker than a razor blade.

However, both in terms of Irish art and British art, Edward is a changeling, in spite of the Tuohy influence, the initial impetus of self-discovery provided by Patrick Swift, and the impact of Lucian Freud. In any case Freud in turn was—in his earlier work at least—greatly influenced by the German painters of the Neue Sachlichkeit (New Objectivity), such as Otto Dix—who in turn again had been influenced by di Chirico, one of Edward's admirations. The fixed, almost glassy stillness which all these artists share, and the sense of intense surface realism with a 'metaphysical' penumbra beyond or behind it, belongs to Continental art rather than British art or Anglo-Irish art. When Swift began to paint, for instance, Magic Realism was still potent on the Continent, particularly in Amsterdam where it had been practised by artists such as Pyke Koch and Charley Toorop. The work of these painters was seen in Dublin in the postwar years. To trace an artistic pedigree for Edward McGuire is unrewarding: better let him speak for himself.

The statement he prepared for the *Artist's Choice* in Belfast is as near as he ever got to a written manifesto of his aims and methods; so I give it here in full.

> I would lay stress on the craftsman's passion; the craftsman's passion is the only thing that humanises art. Unless you come to terms with craftsmanship you can't express your emotion. Art is a science; there are certain rules that should be learned and have to be learned. The Impressionists made that way clear, they used complementary colours and they would not have done the paintings they did if not for the scientific discoveries of Chevreuil.
>
> I find that in order to approach the subject you must have a theory, and the subject and the theory are very important; then it's a question of elimination of excess detail. It's like what van Gogh says, it's rather like taking a watch to pieces and putting it together again. It's a question of knowing your subject intimately, so that you know it so well that you can forget about it and get into the realm of distortion because distortion is the most important thing, I find, in painting. When I mean distortion I mean the confidence to change a line here and change a line there, and that's a very courageous thing.
>
> Abstraction has always existed, there's no such thing as abstract art;

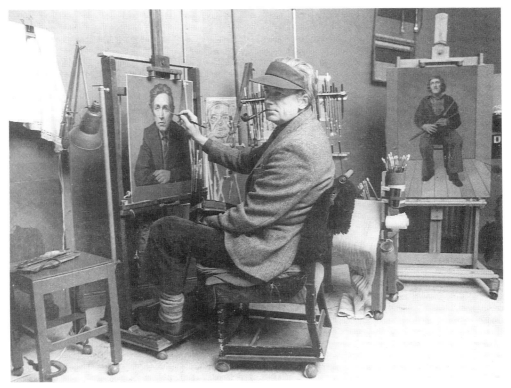

Edward at work in his studio, 1982

Rembrandt's last self-portraits were always abstract. There is no such things as modern art, because all good art is modern.

The subject is terribly important, but I only use it as the starting point for the exploration of complementary colours or tonal values. For instance, between white and black most people would give seven different tonal values; well, I use fourteen. I find that all the poetry exists between one and five. A thing I hope to do one day is modulate, which means using colour to make form, because chiaroscuro does not go with colour since halfway down on the colour scale, colour ceases to exist. It becomes impossible to make it penetrate to the eye at a distance.

I believe that every picture has always been a failure, one has always, at the end of a picture, been discontented with the result, and I regard every picture as being an experiment; it's a question of getting to terms with the physical limitations of the medium of paint, because paint can do so much and so little.

I do four pictures a year at best, and all my preliminary drawing is done on the pictures on the canvas. I use a razor blade a great deal to

rub out; sometimes when you use the razor blade you can get a mar-
vellous quality to put the superimposed paint on top of it. I find one
is mostly groping around these days. . . . It's a question of always
going back to the beginning again, starting from the beginning. It's a
question of going back and discovering and re-analysing, even going
back to one's childhood and, if you can do that, then I think you're
getting some place. I'm not a genius, and when I get my results they
have to be got in a very painful way. I know my limitations and that
is why I lay so much stress on the technical side. Somebody said 'Great
craftsmen were not always great artists, but great artists were always
great craftsmen.' You are completely the slave of paint, and that is
why I say the craftsman's passion is the only thing that humanises art.

My ambition is to stay in one room as long as possible. That's why
I painted it black, so that nothing would disturb me, and it suits the
colour of the pint of stout.

Edward's small, clinical studio was, in fact black and was as unwelcoming as
a dentist's surgery. There was even something of the doctor or anaesthetist about
him as he worked, wearing his green eye shade and with all his paints and
painter's tools laid out with surgical precision; when he studied and measured
you it was as if you were undergoing a medical examination. The bottles of stout
were there too, though in my own experience (and other people's too) when he
wanted a break he and the sitter would go downstairs, perhaps for a drink but
more often for coffee. As he worked he played records, usually jazz, very often
of Billie Holiday. He was, as I have said, very neat and organised in his work-
ing habits and he had even made a kind of wooden frame with clamps in which
he put his primed panels for future pictures. His famous colour dictionary, of
course, was always on hand, and the battered lay figure which had come back
with him from Italy years before.

The colour dictionary cost him years of research and is dated 1958-1968; it is
in the possession of his widow, who allowed me to study it. It consists of a
number of thickish pages most of which are covered with a patchwork of small
coloured squares stuck to the surface of the paper, and looking at first glance
rather like the kind of 'samples' provided by paint merchants, or like a series of
small Vasarely paintings with areas missing here and there. There is a dedica-
tion to his wife inside the cover: 'To Sara from Edward, 25th Dec. 1972'. This
dictionary, the work of a genuine painter-scientist, is surely well worth publica-
tion in a limited edition, for use in art colleges and even in artists' studios. To
grasp it fully would need the experience of a trained and working painter, which

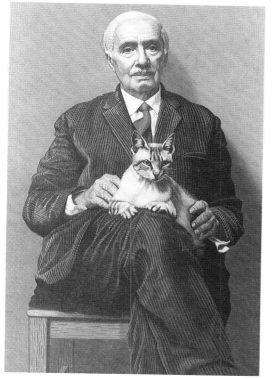

Portrait of Monk Gibbon, 1976

Annontated working drawing for
a portrait of Bruce Arnold, 1986

I am not, or else prolonged study from colour theorists and experts—which again I am not.

Certain things are obvious from even a cursory study; the care Edward took in his tonal transitions from cold to warm, and vice versa. One chart, for instance, illustrates the transition from yellow to violet, and some of the sequences are numbered, 1, 2, 3, 4, 5, etc., recalling Brian Lynch's memories of Edward's numbered drawings. The blues employed are usually cobalt blue, Winsor and ultramarine: and cobalt green is mentioned as a flesh tint. There are intricate codes for mixing colours, and a note for the background of the Francis Stuart portrait lists '1 cobalt blue, 1 Fub [or Fud], 2 burnt sienna-roller.' If the reading is 'Fub' this means French ultramarine blue; if 'Fud' is the actual reading, it stands for French ultramarine deep. Other transitions which are charted are from cadmium red deep into Winsor blue, and from burnt sienna to cobalt blue.

Sally also has preserved many of his paint tubes, among which yellow ochre is very prominent. In the 1980s he used board more and more, instead of canvas, and he always prepared his own grounds, using glue size and a coat of white. He also used retouching varnish and in the very last years, I am afraid, he used it too often and too thickly, giving a slightly tacky surface. By then his

77

Colour dictionary and unfinished portrait
of Maurice Craig

touch had coarsened slightly but perceptibly, and his tonal gradations lacked the old subtlety and authority. The unfinished portraits make a strange ghostly impression, as though silently awaiting the painter's return or resurrection to bring them to life, as only he could. As I mentioned earlier, the lay-in of the faces is in green, and Maurice Craig's sweater, which was to be white in the finished picture, is underpainted in a dead, neutral, brownish colour.

It was Edward's tragicomedy to be regarded as a realist, both by his *avant-garde* denigrators and his less critical admirers. The dreamlike twists and dislocations of perspective he employed, and his subtlety in foreshortening, seem largely to have been wasted on them. For anybody who has looked at one of his best pictures with care and has sunk himself into them, their basically abstract quality will be clear, their silence and strangeness, nearness and remoteness. Edward was not a Modernist, he was a 'modern'. When he said to me that he would like to put his sitters in a fridge and take them out as and when he pleased, he was enunciating an aesthetic and not a whim: after all the great German art scholar and critic, Julius Meier-Graefe, has written that all painting is essentially still life. This does not mean that Edward's portraits lack humanity, or a sense of the sitter's individuality. Of course they have such qualities, but what ultimately is more enigmatic than the human presence? That is the message of Giacometti's paintings, which are at once intimate and remote; and perhaps Edward, if he had known it, would have endorsed di Chirico's motto, *et quid amabo, nisi aenigma est?*

PORTRAITS

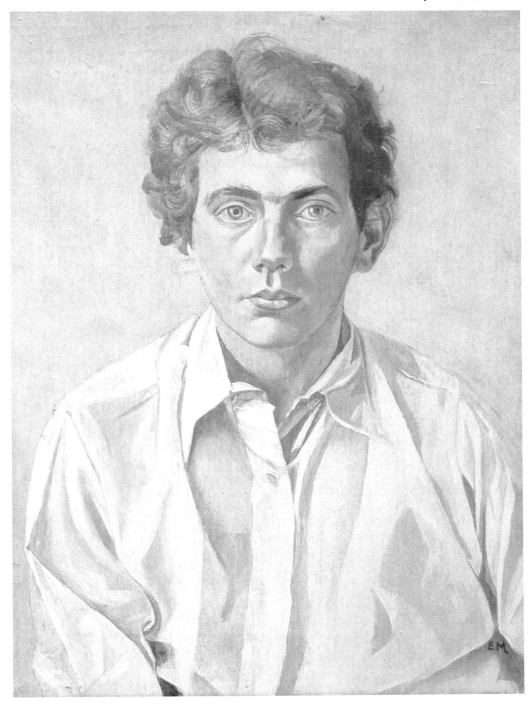

2 Patrick Kavanagh, 1961, CAT. 10

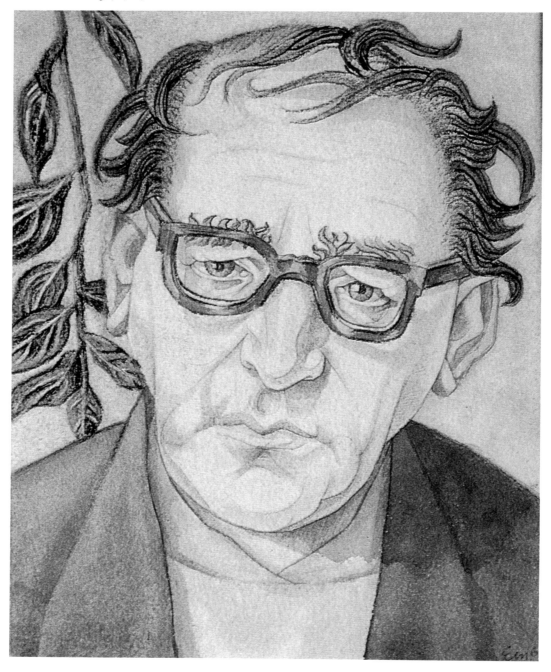

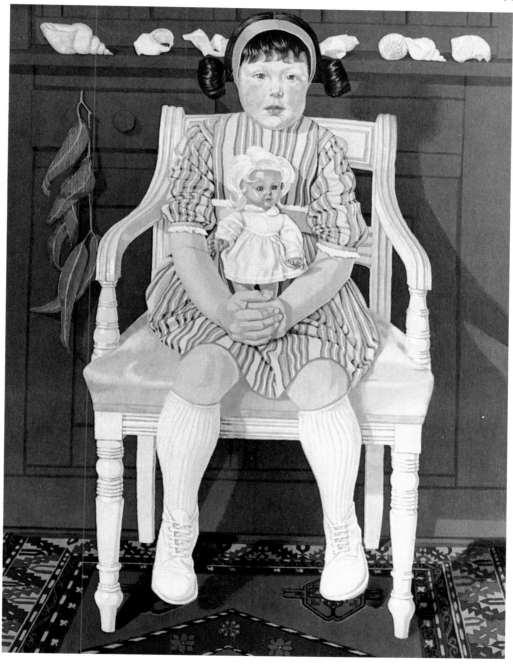

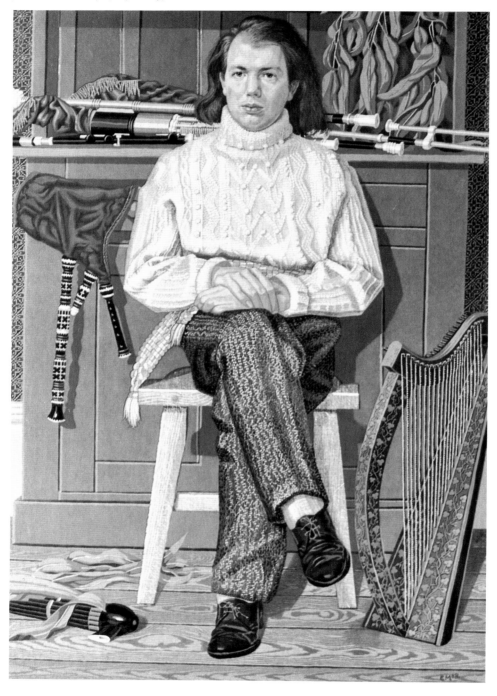

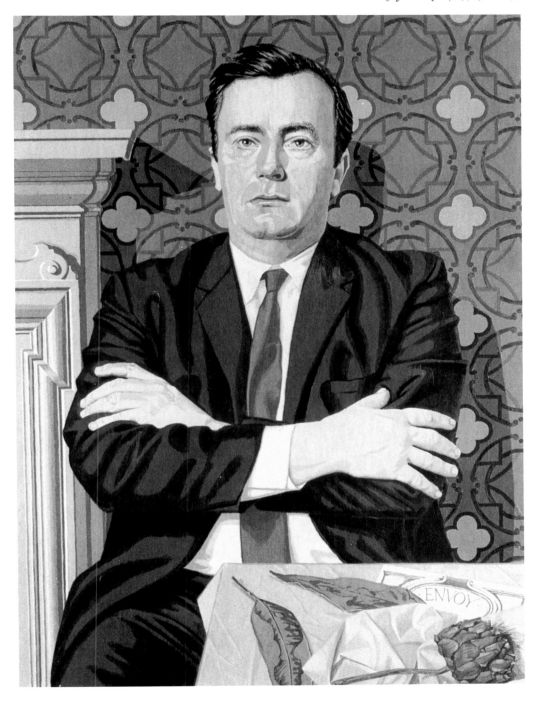

Edward could deploy a nifty brand of hauteur—for which he was well equipped: he was exceptionally handsome; he was tall; and he'd been to a posh 'public' school. He had, in fact, the sort of presence often called commanding.

To suffer fools gladly was not one of his failings. The first time we met was also the only time I was ever on the receiving end of his hauteur. Perhaps he took me for a fool; we certainly misunderstood each other; we were both in our cups. We didn't meet again for several years, but when we did we got on famously.

Whenever, in McDaid's, the holy hour belatedly struck, Edward, who was anything but mean, was given to inviting a kindred spirit or three to Bewley's; where, one day, we were no sooner seated (with John Jordan and Justin O'Mahony) than we heard, from a nearby table, a West Briton loudly running down the Irish. Without deigning to rise, Edward drew himself up to his most commanding, and, in his very 'best' accent (which was, of course, much 'better'), delivered a short, sharp, well-phrased rebuke. I'm sure he enjoyed his own hauteur as much as we did.

He came to my home only once, to discuss the portrait. We spoke of owls and dandelions. He fell in love with a marble fireplace and wanted to buy it. I was hard-up, and would gladly (though reluctantly) have sold it, but I felt the landlord might not be too pleased. Edward seemed disappointed in my failure of nerve.

One of the last times we met was at an Aosdána meeting. We sat side by side. The meeting was long, and not consistently enthralling. Halfway through, Edward began to draw, in black. Pretending not to, I watched an owl take shape. Soon enough he pushed it across to me, complete with title—Barney the Barn Owl—and a warm inscription. It graces the marble mantelpiece.

PEARSE HUTCHINSON

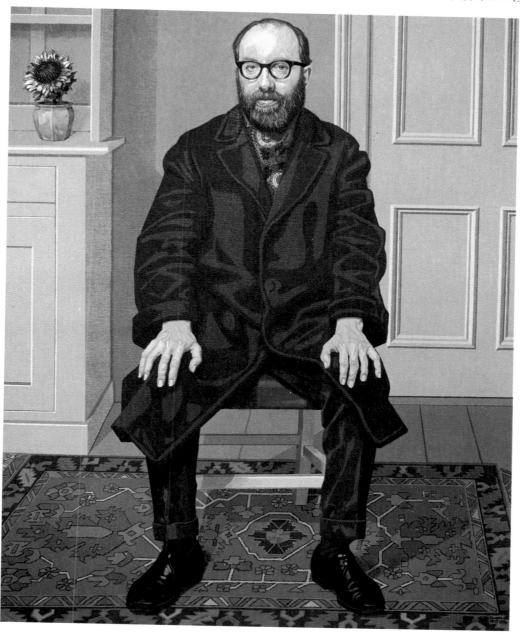

I spoke to a lone plover
in no uncertain fashion
'What feather of a lover
do you seek with such passion?'

Its piebald, reptile glance
marbly regarded me.
Its plumed, nunlike stance
disconcerted me.

'Can you not see the female curve
beneath this down.
nor in this birdlike frown
detect a moving nerve?'

It clawed me, shrieking, human,
and fled across the park.
Perhaps the internecine dark
made it a running woman.

MICHAEL HARTNETT

*See also Michael Hartnett, 'A Sitter Remembers . . .' at CAT. 47 below.

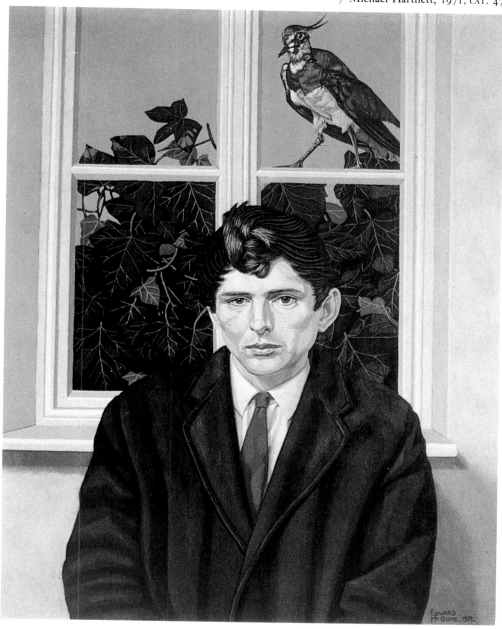

8 **Nuala,** 1973, CAT. 61

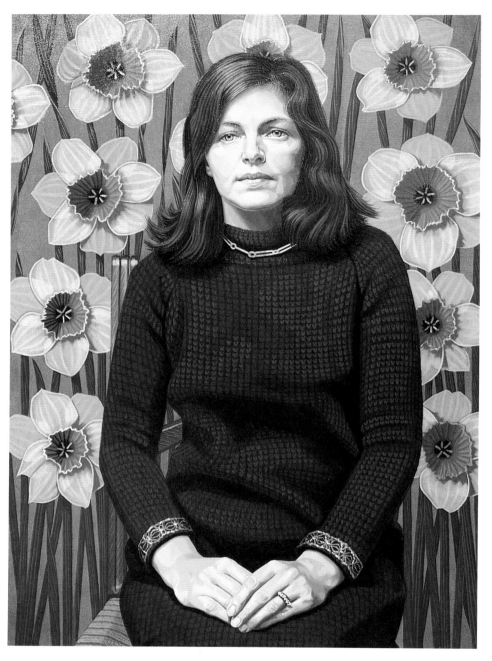

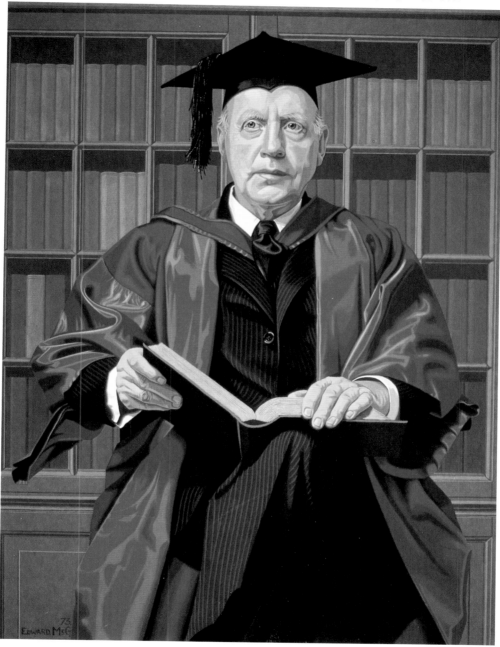

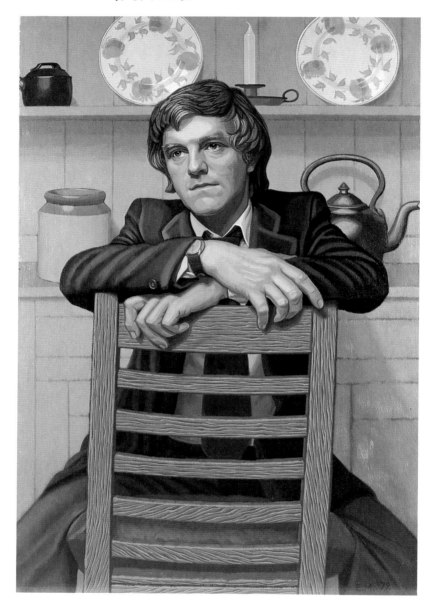

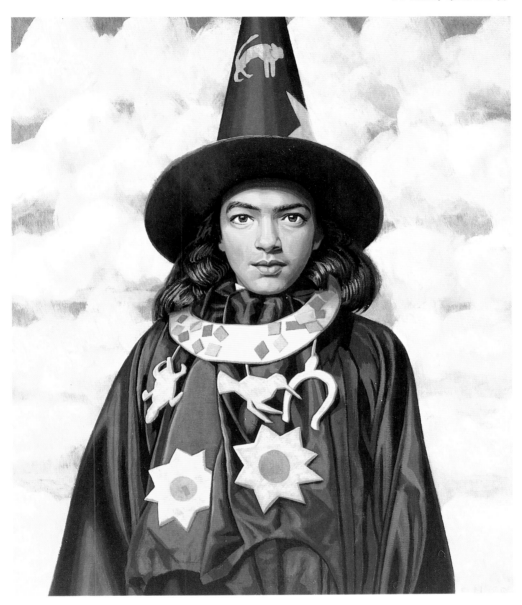

A BASKET OF CHESTNUTS

There's a shadow-boost, a giddy strange assistance
That happens when you swing a loaded basket.
The lightness of the thing seems to diminish
The actual weight of what's being hoisted in it.

For a split second your hands feel unburdened,
Dismayed, passed out, gone through.
Then just as unexpectedly comes rebound—
Downthrust and comeback ratifying you.

I recollect this basket full of chestnuts,
A really solid gather-up, all drag
And lustre, opulent and gravid
And golden-bowelled as a moneybag.

And I wish they could be painted, known for what
Pigment might see beyond them, what the reach
Of sense despairs of as it fails to reach it,
Especially the thwarted sense of touch.

Since Edward McGuire visited our house
In the autumn of nineteen seventy-three,
That basketful of chestnuts shines between us,
One that he did not paint when he painted me

Although it was what he thought he'd maybe use
As a decoy or a coffer for the light
He captured in the toecaps of my shoes.
But it wasn't in the picture and is not.

What's there is comeback, especially for him.
In oils and brushwork we are ratified.
And the basket shines and foxfire chestnuts gleam
Where he passed through, unburdened and dismayed.

SEAMUS HEANEY

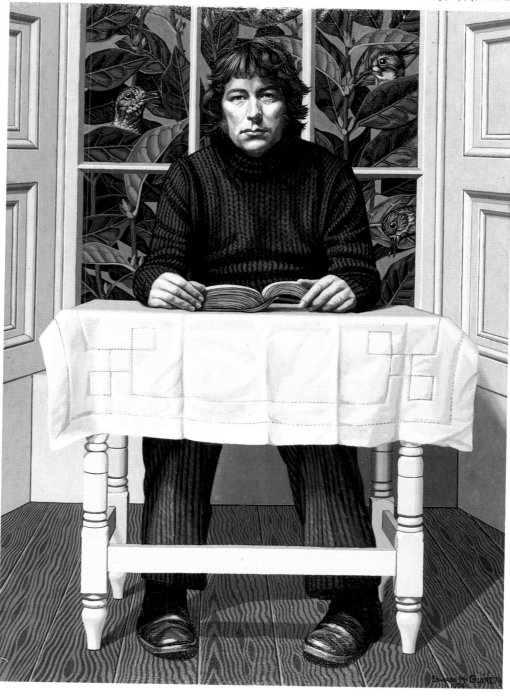

Eddie first talked about doing a portrait of me in his old studio in Leeson Street, where we sometimes went back to have another drink or a meal out of the pressure cooker which in those days was his solution to the eating question. He was then painting what I think was almost his first portrait in oils, the one of Garech de Brun. He had Garech's Aran pullover on a lay figure and he seemed to be months at it, painting it thread by thread. 'I want to do you next,' he would say. I would make a joke about not having any clothes to spare that he could work from in my absence and we would agree that I might manage to wear a shirt I could leave behind.

In fact I was not next and he had begun to live in Sandycove and painted quite a series of literary figures before he got around to me. Every time we met he would talk about beginning immediately, and after he had done Francis Stuart he started to phone me late at night to say he wanted to do me in a white shirt like Francis, so that we could hang in the Municipal together. He even did a pen and ink drawing one day in McDaid's; but there was no painting and I am afraid that I had begun to make comments about others being preferred before me while he was still protesting his intent.

I think he wanted to paint something freer than the very meticulous portraits he had done up to then, but he did not know quite how to go about it. Much of our conversation at the time was concerned with the necessity for an easier and less uptight approach. 'You should start tight and work loose', he would say.

I finally got painted because he was the subject of a television programme and it would appear that after the first day he refused to talk any more to the television interviewers, declaring that he would talk to me while he painted me instead. So he had to begin and the first session was in front of the cameras while he did the charcoal drawing that formed the basis for the painting.

He called the almost monochromatic result his 'brown study' and I think it was actually a new departure for him at the time, though the objects in the foreground were as tightly painted as ever. I don't know why he chose the cooking pot and the old-fashioned iron. I suspect he just wanted to paint them, but maybe there is a faint advertence to Leeson Street, the meals we had out of the pressure cooker and the shirt I never did leave behind.

ANTHONY CRONIN

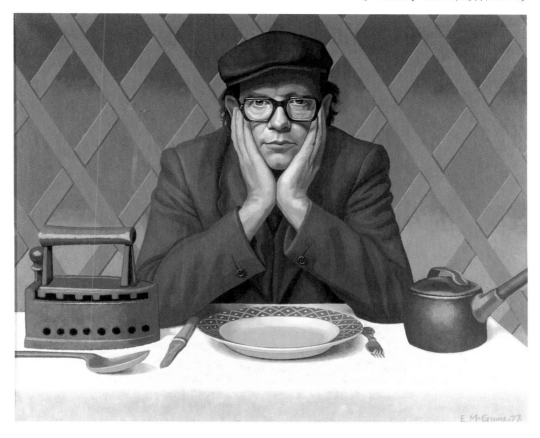

14 Paul Durcan, 1981, CAT. 105

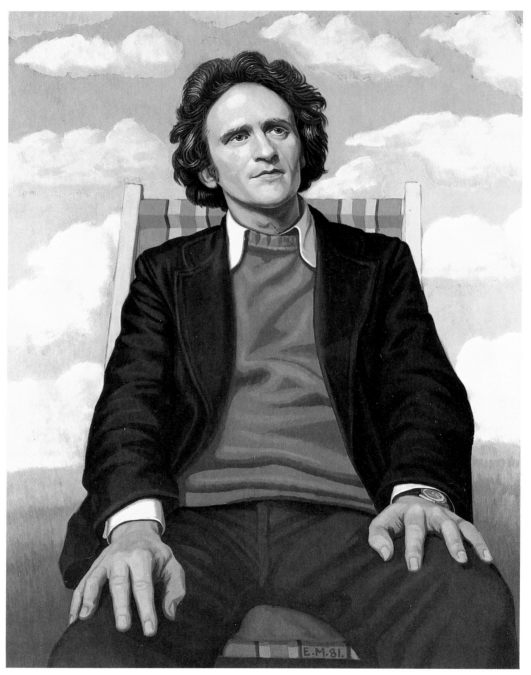

PORTRAIT OF THE PAINTER
AS A CREATURE OF PAINSTAKING COURTESY

My mother is sitting alone at my bedside.
A knock on the door. The door opening.

Chiaroscuro man in sunglasses and curls
Gripping, as 'twere the reins of a white horse,
The handle of a canvas shopping sack
Brimming with vegetables and fruit.

He visits for twenty minutes
Conversing with my mother
About vegetables and fruit—
Price vis-a-vis quality.
Leeks and avocados are what he vouches for
But my mother expostulates
She lacks experience of leeks and avocados.
I sit up in the bed, listening in consternation
To the pair of them, total strangers
Being truly polite to one another.

He plunges his hand down into vegetables,
Fetches up a book wrapped in newspaper;
A small volume in red cloth and gold tooling,
The Discourses of Sir Joshua Reynolds;
On the flyleaf in flowing hand in black ink
His name, address, telephone number.

'Paul, this is the book in which Reynolds—
Reynolds says it all.
It will help you to get well.
Return it to me when you're recovered.'

When he stands up to take his leave
And holds out his hand to shake my mother's hand,
He bends down and kisses the back of her hand,
The small, fraught back of her hand.
She's not accustomed to the outrage of courtesy.

In the open door he glances back over his shoulder
And employing the Italian form of farewell
Pianissimo he pronounces it: *Salute*.

When the door closes behind him
My mother sits upright in her chair
And I lie back down in the bed
In silence. Plumbing humming.
She cries out: 'Who was that man?
I've never met a more courteous man in my life.'

On a cold Spring day
I walk across Scotman's Bay
To return to the most courteous man
My mother ever met in her life
The book in which Reynolds—
Reynolds says it all:
The great end of the art is to strike the imagination . . .
The spectator is only to feel the result in his bosom.

PAUL DURCAN
Feast of the Epiphany, January 6, 1991

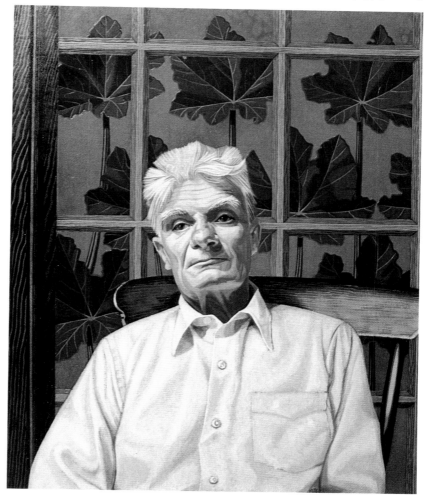

Edward McGuire's portrait of me I am particularly fond of for several reasons. With several others to chose from, my publishers and I selected it as the cover for a biography of me written by Geoffrey Elborn and brought out by RAVEN ARTS earlier this year.

Although painted partly from photographs, there were a number of sittings toward the end of the work at Edward's house and we became friends.

The portrait hangs in the Municipal Gallery where I have a look at it from time to time and recall my friend.

Last time I was there, there stood someone in front of the picture and although we did not know each other we began to talk of Eddie and old times which I know would delight him.

FRANCIS STUART

SITTING FOR EDDIE
in memory of Edward McGuire

I had suggested a spray of beech leaves behind me
Or a frieze of birds—bittern, lapwing, chough—
Or a single carline-thistle representing flowers
Pressed between pages, stuffed birds behind glass, our
Still lives, Eddie's and mine, feathers and petals
That get into the picture like noises-off, long
Distance calls in the small hours, crazed arguments
About the colour of my eyes—his strange mistake—
Jazz to relax me, in an enormous magnifying
Glass our eyes out of all proportion, likenesses
And the trundle of castors under a skylight,
His gambler's eye-shield, the colours of the rainbow,
Me turning into a still life whose eyes are blue.

MICHAEL LONGLEY

*See also a note on this poem at CAT. 125.

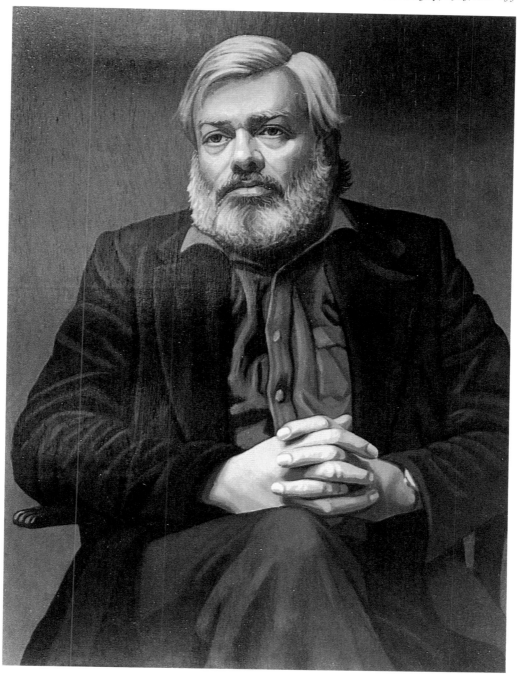

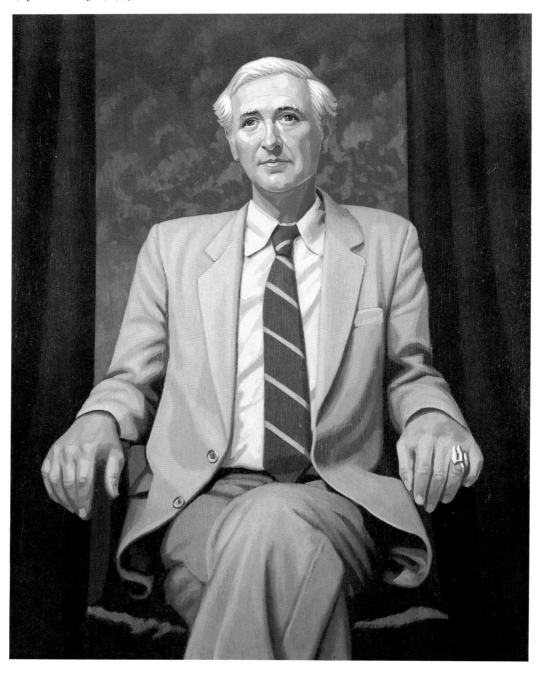

THE YACHTSMAN'S JACKET

A portrait of Edward McGuire, RHA

Eddie, old friend, gone to the shades,
We both walked a while on the wild side.
You endeared yourself to me first
As you swayed above your father's swimming pool
And pronounced: 'Let's have a piss!'

Two golden arcs in the Blackrock night.
Viking berserk, your drinking bouts:
Wrecking Garech Browne's Quinn's Lane flat
In a fracas with Dominic Behan,
Angry, after you had upended Kathleen.

And as I was crashing a party in Sandymount
You came hurtling, backwards, out.
You stopped to say, 'Hello, John', then
Lowered your head to charge in again,
Waving a weapon, a bottle of stout.

Your humour as wayward as your anger.
Standing beside Barrie Cooke in P. Pye's flat
When Barrie, per usual, ripped a fart,
You unfolded your lean height, to declare:
'Picasso, perhaps, but a miserable painter from Clare

Has no right to pollute my air.'
Behind all the rattle, awkwardly shy,
The unhealed hurt of a mother's boy,
All the lostness wrought to tension, fury
Of contemplation, schemes of colour harmony,

The sitter's face, but the leaf at the window.
Your freudian trademark: that spiky dead bird.
Though you were gentle as you were wild,
Charting the glooms of our middle-class Bohemia,
But also a tender portrait of a girl child.

In due course, I joined your gallery,
To be received with old world courtesy,
Before we clambered to your studio:
The draped camera, plus the green visor
To enable you concentrate on your task.

I was still convalescent at the time,
So you hovered over me, like a mother hen,
Sending for hot lunches, wine or stout,
A couch to curl away, for the afternoon,
Punctiliously paying taxis, in *and* out.

Brushing slowly, with fastidious skill,
Sadly you confide: 'I have to live alone,
Otherwise, I can get hardly anything done,
Which is hard, when you also love them.'
A ring from Ted Hickey in the Ulster Museum,

And you came back, rubbing your hands:
'It's in the bag, a first, sight unseen.'
Downstairs, a taciturn Cosgrave waited,
Next in line. Paid by the Cumann.
You grinned: 'He's too stiff to be human.'

It was rainy and cold when I left,
So you settled your navy blue jacket
Over my shoulders. 'I won't need it,'
You expostulate gently. Its bulk protects
Me still as I walk fields of West Cork.

JOHN MONTAGUE

STILL LIFE

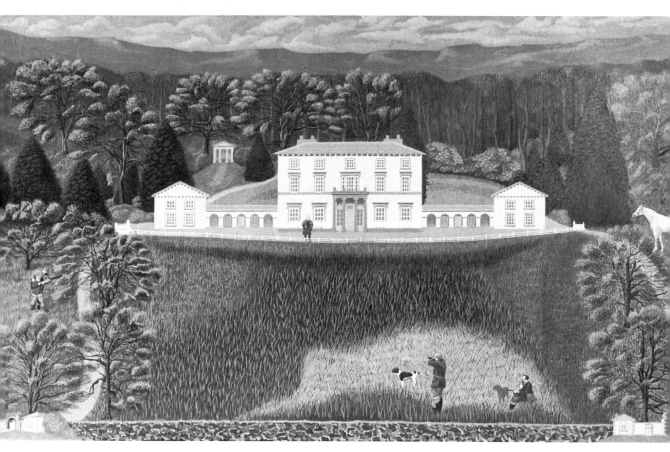

19 Still life—Skull, 1954, CAT. 11

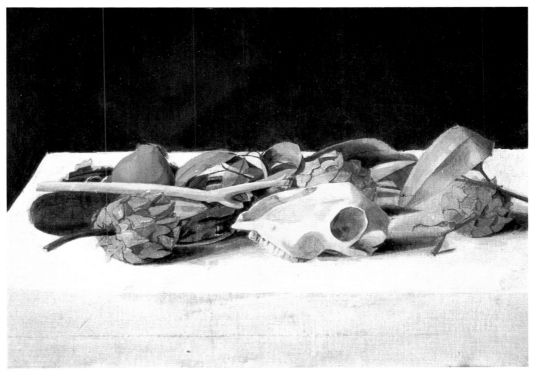

20 The Window, 1974, CAT. 65

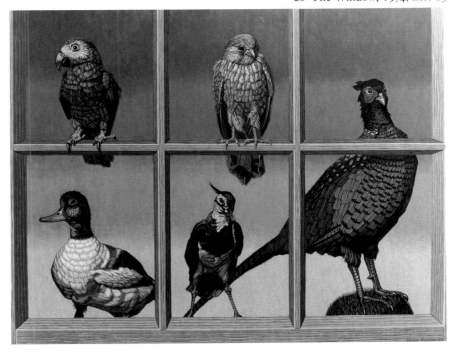

21 Four Snipe, 1969, CAT. 41

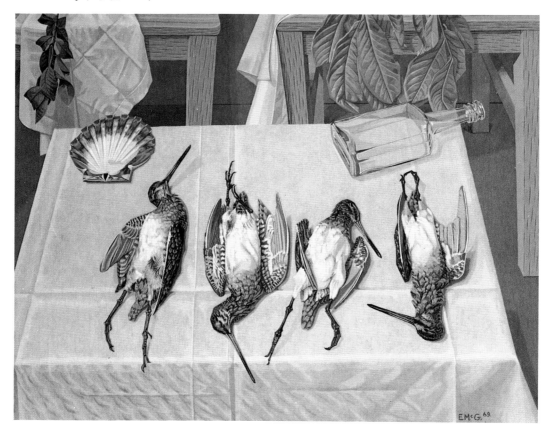

22 Waterhen, 1969, CAT. 40

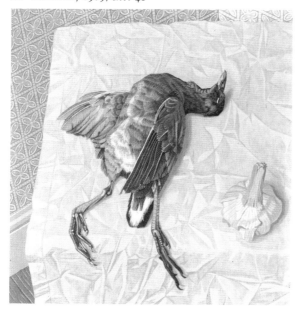

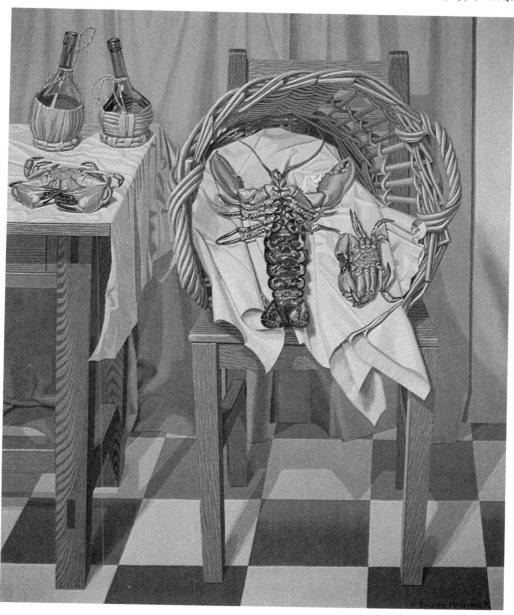

24 Owl—Moonlight, 1973, CAT. 59

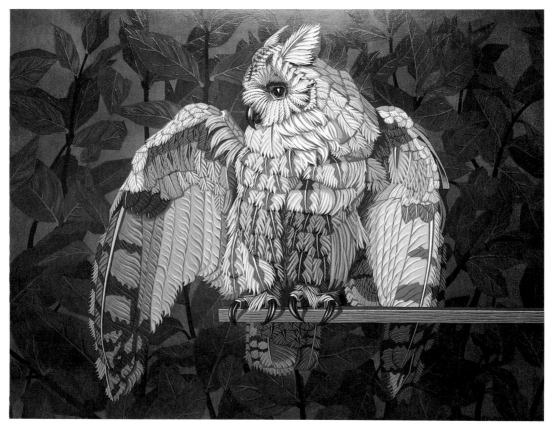

25 Barn Owl, 1985, CAT. 154

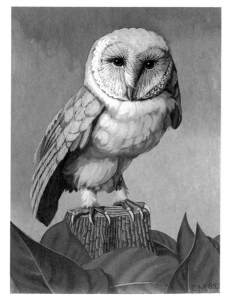

26 Owl II, 1972, CAT. 52

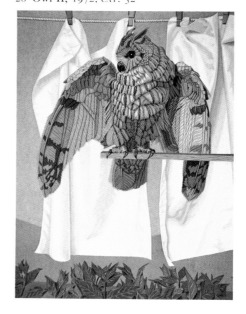

CATALOGUE

Note on the Catalogue

THIS CATALOGUE of my late husband's works I began shortly after he died in November 1986. Theo Snoddy, who was compiling a continuation of *Strickland's Dictionary of Irish Artists,* had visited me. He was disconcerted to find that there were no catalogues of one-man exhibitions by Edward and, therefore, no easy way for him to document the artist's life's work.

So I began to collate the information I had to hand: a ledger in which I had entered all Edward's works of the 1970s, notes I had taken during the 1980s from conversations with him (these included titles of early works from the 1950s and 1960s), letters, photographs and clippings in his studio files. I studied catalogues of all the open submission exhibitions where he had shown: IELA, 1953–63; RHA, 1962–86; the Oireachtas where he exhibited occasionally from 1973 to 1980; and all the selected exhibitions which included his work. Unfortunately many of these early catalogues omit essential details such as dimensions and medium, giving only the title and name of the artist. An open letter to the *Irish Times* appealing for information about early works brought disappointingly few replies.

An unexpected frustration in my search was explained when John Taylor, of the Taylor Galleries (from 1978–86 Edward's agent) told me that all records of the Dawson Galleries (who were precursors to the Taylor Galleries) prior to 1977 when Leo Smith died, were now unobtainable. As the Dawson Galleries, under the aegis of Leo Smith, were Edward's agents during a very important period of the artist's work—from the 1960s to 1977—this was a severe setback in my research.

With the above proviso I submit this catalogue of the works of Edward (Augustine) McGuire not as definitive, although all the details given are accurate to my knowledge, but as a seminal compilation of his works which I hope will assist future researchers, students and collectors.

Dimensions are given in inches, height preceding width. Explanations of some acronyms and Irish terms which may be helpful to some readers, are given below.

S. McG

Aosdána	Literally, men of art. An institution established by the State in December 1981 to honour those Irish artists in the disciplines of music, literature and the visual arts whose work has made an outstanding contribution to the arts in Ireland. Members of Aosdána are elected by vote. Membership is limited to 150.
IELA	Irish Exhibition of Living Art. An annual, open-submission exhibition. Exhibitors must be resident in Ireland.
Oireachtas	An annual, open-submission art exhibition. All entries must be titled in the Irish language.
RHA	Royal Hibernian Academy. An annual open-submission exhibition; selection is by committee. Members of the RHA are elected by vote and are entitled to hang up to seven works. Full membership is limited to 25. Established 1823.
ROSC	Literally, the poetry of vision. A committee-selected exhibition held every four years in Ireland and including works of artists world-wide.
Saoi	Literally, wise man. Significant achievement in an art form is recognised within Aosdána by the 'Saoi' honour. To date only three persons have been elected Saoi—Samuel Beckett, Seán O'Faolain, and Patrick Collins.
Taoiseach	Prime minister of Ireland, leader of the Government.

* Works marked by an asterisk are illustrated in the colour plates.

1
Self-portrait. 1950
18 x 15. Oil on canvas.
Private collection.
Provenance: artist; owner.
*Painted during the artist's first visit to Italy,
aged eighteen.*

2
Portrait of Matti. 1953
26 x 16. Oil on canvas.
Signed: EA 53.
Exhibited: IELA 1953, cat. 73.
Privately owned.
Provenance: 1970s' auction; owner.
*Matti Klarwein was a fellow student at the
Academy of Fine Art in Rome.*

3
Bird. 1953
Still life.
Exhibited: IELA 1953, cat. 68 (Edward
 Augustine).

4
Plover & Snipe. 1953
Still life.
24 x 18. Oil on canvas.
Exhibited: IELA 1953, cat. 75 (Edward
 Augustine); Taylor Galleries, Dublin,
 1978.
Private collection.
Provenance: Taylor Galleries 1978; owner.

5
Trees. 1954
Landscape.
Exhibited: IELA 1954, cat. 34 (Edward
 Augustine).
Private collection.

6
Bird. 1954
Still life.
Exhibited: IELA 1954, cat. 39 (Edward
 Augustine).

7
Hens. 1954
Still life.
Exhibited: IELA 1954, cat. 81 (Edward
 Augustine).

8
Portrait. 1953.
Self-portrait.
52½ x 37½. Oil on canvas.
Exhibited: IELA 1954 cat. 57 (illustrated
 b/w).
*This self-portrait was later destroyed by the
artist.*

9
***Self-portrait.** 1954
12 x 9. Tempera on canvas.
Signed: EM
Exhibited: Artist's Choice, Ulster Museum
 1973, cat. 1; RHA memorial section 1988,
 cat. 250.
Private collection.
Provenance: purchased from the artist 1954.
Painted while at the Slade School in London.

10
Still life. 1954
Chester Beattie collection.

11
***Still life—Skull.** 1954
10 x 14. Oil on panel.
Signed: EM 54.
Inscribed reverse: Edward McGuire 1954.
Exhibited: Artist's Choice, Ulster Museum
 1973, cat. 7; RHA memorial 1988, cat.
 251; Expression '87, Dun Laoghaire Town
 Hall, cat. P.
Private collection.
Provenance: artist; Claire McAllister; owner.
Painted during first visit to the Aran Islands.

12
Bird & Skull. 1954
Still life.
Exhibited: IELA 1955, cat. 26 (£25)
 (Edward Augustine).

13
Still life. 1955
Exhibited: IELA 1955, cat. no. 12 (£65)
 (Edward Augustine).

14
Self-portrait. 1955
Exhibited: IELA 1955, cat. 27, nfs
 (Edward Augustine).

15
Bird with Cabbage. 1954
Still life.
24 x 20. Oil on canvas.
Signed: EA 54.
Private collection.
Provenance: artist; owner.

16
Portrait of a Girl. 1955
28 x 22. Oil on canvas.
Exhibited: IELA 1958, cat. 70, nfs.
Private collection.
Provenance: artist; owner.
Unfinished portrait of 'Rita'.

17
Dead Sheep. 1956
Still life.
8 x 14. Watercolour sketch; pencil & wash.
Inscribed reverse: 'Arran [*sic*] Isles 56.
 Edward McGuire. Dead sheep. 18 gns.'
Private collection.
Provenance: J. Adam & Sons auction 1987;
 owner.
*Painted during the artist's second visit to the
Aran Islands when he rented a cottage near
Kilmurvey.*

18
Waterhen. 1956
Still life.
12 x 9. Oil on canvas.
Signed: EA.
Exhibited: Ritchie Hendriks Gallery group
 show 1956.
Private collection.
Provenance: Ritchie Hendriks Gallery 1956;
 owner.

19
Still life. 1957
Exhibited: Artist's Choice, Ulster Museum
 1973, cat. 12.
Private collection.
Provenance: Dawson Gallery; Jonathan
 Irwin; via Taylor Galleries; owner.

20
Still life. 1957
Exhibited: IELA 1959, cat. 142 (£20)
 (Edward A. McGuire)

21
Moorhen. 1958
Still life.
12 x 9. Oil & gouache sketch; oil on panel,
 grisaille.
Inscribed reverse: Edward McGuire 1958.
 Rock House.
Private collection.
Provenance: artist; owner.
*Painted during one of many visits to a friend's
shooting lodge in Co. Mayo.*

22
Cabbage. 1959
Still life.
Exhibited: IELA 1959, cat. 31 (£15)
 (Edward A. McGuire).

23
Dead Bird. 1959
Still life.
14 x 11. Oil on canvas.
Signed: Edward A.
Exhibited: IELA 1959, cat. no. 28 (£12)
 (Edward A. McGuire).
Private collection.
Provenance: IELA; Gwladys McCabe; by
 descent; owner.

24
Still life—flower pots. 1956
Oil on canvas.
Provenance: returned to studio *c*.1970, resold
 Dawson Gallery; owner.

25
Pintail. 1960
Still life.
14 x 20. Oil on panel.
Private collection.
Provenance: artist; owner.
Pintail duck with scallop shells.

26
Portrait of John Kilbracken. *c*.1960
Watercolour portrait.
Private collection
Provenance: artist; owner.

27
Still life. 1961
Exhibited: IELA 1961, cat. 109 (£60)
 (Edward McGuire)

28
***Portrait of Patrick Kavanagh**. 1961
10 x 8. Watercolour on paper.
Exhibited: Claddagh Records group
 exhibition, David Hendriks Gallery 1970,
 cat. 22; Artist's Choice, Ulster Museum
 1973, cat. 11.
Private collection.
Provenance: artist; owner.
*Portrait of the Irish poet (1904-67) best known
for* Tarry Flynn *(novel),* The Green Fool
*(autobiography) and his poetry. This is the first
known portrait by the artist of a poet and the
start of a lifelong commitment to the painting
of portraits of living Irish poets whom he knew
personally.*

29
Still life. 1962
Watercolour.
Exhibited: RHA 1962, cat. 150, nfs.

30
Self-portrait. 1962
Watercolour.
Exhibited: RHA 1962, cat. 196, nfs.

31
Portrait. 1962
Watercolour.
Exhibited: RHA 1962, cat. 202 (£50).

32
Study—Two Birds. *c.*1962
Still life.
67 x 45. Conté & tempera/canvas.
Private collection.
Provenance: artist; Eamonn McEnery; owner.
Study/exercise work from Audubon's Birds of
America.

*During the years 1962-66 the artist worked on
experimenting with colour, seldom completed
paintings and did not exhibit new works. He
compiled his 'colour dictionary'. Works on
exhibition were often borrowed—therefore 'nfs'.*

33
Still life. 1963
Exhibited: IELA 1963, cat. 45, nfs.

34
***Portrait of Wanda Ryan**. 1963-66
32 x 23. Oil on canvas.
signed: EM.
Exhibited: IELA. 1963, cat. 1, nfs; 'Wanda'
 RHA 1968, cat. 1, nfs; 'Portrait', Artist's
 Choice, Ulster Museum 1973, cat. 3,
 'Portrait of Wanda Ryan'.
Private collection.
Provenance: artist; owner.
Private commission.
*This portrait of a child, seated with a doll on
her knee, was the first commission the artist
received. It was finally completed in 1966 but
had been exhibited unfinished as early as 1963.*

35
Portrait of the Artist's Grandmother.
 1966
30 x 26. Oil on canvas.
Privately owned.
Provenance: artist; owner.
*This portrait of the artist's paternal grandmother
was not painted from life. It was an exercise
work painted during the years 1962-6. This
version has palm fronds on the table.*

36
Portrait of the Artist's Grandmother.
 1966
40 x 30. Oil on canvas.

Privately owned.
Provenance: artist; owner.
Portrait of the artist's paternal grandmother, not painted from life, an exercise work painted during the years 1962-6. This version has eucalyptus leaves on the table, a recurring motif in the artist's work.

37
Still life—Bird. 1967
11 x 9. Oil on panel.
Signed: EM. 67.
Privately owned.
Provenance: artist; J.F. McGuire; by gift; owner
Bird with shells on dresser.

38
***Rossenarra.** 1967
Landscape.
30 x 48. Oil on canvas.
Exhibited: RHA 1968, cat. 81, nfs; RHA memorial section 1988, cat. 247.
Private collection.
Provenance: artist; owner.
This 'landscape' was commissioned. It depicts the owner of the property, Rossenarra, with his nephew, Eamonn, keepers, dogs and stallion, Palestine. The figures are small and the painting is dominantly of the house and landscape surrounding it. It is one of only three such 'landscape/portraits' by the artist. Sir John Lavery died at Rossenarra. (See CAT. 100 and 107.)

39
***Portrait of Garech Browne.** 1968
53 x 38. Oil on canvas.
Signed: EM 68.
Exhibited: RHA 1970, cat. 50, on loan; Artist's Choice, Ulster Museum 1973, cat. 10.
Private collection.
Provenance: artist; Oonagh Lady Oranmore and Browne; by descent; owner.
Garech Browne (de Brun) initiated the Claddagh Record Company to record poetry, traditional Irish music and music of contemporary Irish composers; he also started 'The Chieftains' (see CAT. 113.). Garech is seated on a traditional three-legged west of Ireland chair

wearing an Aran sweater, Aran tweed trousers and crios. On the dresser are uillean pipes and a Breton binion, on the floor a Japanese sho.

40
***Waterhen.** 1969.
Still life.
18 x 16. Oil on canvas.
Signed: EMcG 69.
Exhibited: Artist's Choice, Ulster Museum 1973, cat. 9.
Private collection.
Provenance: artist to owner.

41
***Four Snipe.** 1969
Still life.
23 x 28. Oil on canvas.
Signed: EMcG 69.
Private collection.
Provenance: Dawson Gallery; the Hon. Mrs Dominick Browne; via Dawson Gallery, John F. McGuire; owner.
Exhibited: Dawson Gallery 1969 first one-man show: exhibition of this one, single painting; The Delighted Eye/A Sense of Ireland: touring exhibition 1980, cat. 48.
The artist considered this painting his most important still life to date. Leo Smith of the Dawson Gallery must have agreed; giving on exhibition of one painting was, and still is, very unusual. The painting is of four dead snipe laid on a white cloth on a table with a scallop shell and green glass bottle. Two oak chairs with cloths and sprays of foliage fill the top of the canvas. The chairs and table appear in later works (see CAT. 48.) While in progress, the canvas travelled with the artist to Toulouse in France.

During the same year, 1969, the first profile in print about the artist appeared in Magill *magazine. During the following decade, many of his most important works were painted.*

42
Bread & Green Bottle. 1970
Still life
12 x 9. Oil on panel.
Private collection.
Provenance: artist; Eamonn McEnery; by gift to owner.

43
Sketch for a portrait of Tiger. 1970
10 x 7. Watercolour on greaseproof paper.
Signed: EMcG.
Private collection.
Provenance: artist; owner (see CAT. 44.)

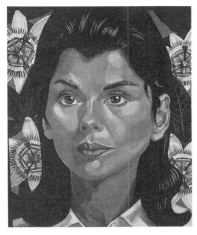

44
Portrait of Tiger. 1970
10 x 8½. Oil on panel.
Signed: EM 70.
Private collection.
Provenance: artist to owner by commission.
Portrait of the Countess Cowley, head and shoulders wearing a white shirt with background of four passion flowers.

45
***Portrait of Pearse Hutchinson.** 1970.
52 x 42. Oil on canvas.
Signed: Edward McG. 1970.
Exhibited: Claddagh Records' group exhibition, David Hendriks Gallery 1970, cat. 24; IELA 1971, cat. 45. nfs; 'The Irish Imagination', Hugh Lane Municipal Gallery 1971, cat. 15. and Washington DC, Philadelphia and Boston; Artist's Choice, Ulster Museum 1973, cat. 6; Sixth Festival International, Cagnes-sur-Mer 1974, diploma award, illustrated b/w; RTE film 1977.
Private collection.
Provenance: Dawson Gallery;
John Jay; by descent to present owner.
Pearse Hutchinson, poet, born in 1927, is a member of Aosdána.

46
***Portrait of John Ryan.** 1970
29 x 23. Oil on canvas.
Signed: EM 70.
Exhibited: RHA 1970, cat. 95 nfs; Artist's Choice, Ulster Museum 1973, cat. 4, nfs.
Private collection.
Provenance: artist; John Ryan; owner.
John Ryan, born 1925, a critic and painter, was editor of Envoy *and the* Dublin Magazine.

47
***Portrait of Michael Hartnett.** 1971
30 x 24. Oil on canvas.
Signed: Edward McGuire 1971
Exhibited: RHA 1971, cat. 51, nfs; 'The Irish Imagination', Hugh Lane Municipal Gallery of Modern Art 1971 and Washington DC Philadelphia and Boston USA, cat. 16. illustrated b/w, catalogue article by John Jordan; RTE film 1977.
Private collection.
Provenance: Dawson Gallery; present owner.
This portrait of the Irish poet Michael Hartnett (born 1941), member of Aosdána, was uncommissioned, as were most of the artist's portraits of poets. The poet is placed before a window behind the four panes of which ivy leaves reach upward and a bird, a lapwing (sometimes called plover), stands.

In a letter of 19 October 1990 to Sally McGuire, Michael Hartnett writes: 'The poem I enclose [for this book, used on page 88] was a favourite of Edward's—in fact he used the "lone plover" as a background in the portrait.'

In the Irish Arts Review, *vol. 4, no. 4 (Winter 1987) reproduced below by kind permission of the* Review, *the poet remembers Edward McGuire: 'I had never sat for an artist, indeed was very much afraid of doing so then, in the early seventies, as I am now. But I had sat with an artist, Edward McGuire, many times and in many pubs. One day he said he wished me to sit for a portrait. I was certainly flattered, if timorous. He had been working on (or intended to work on) portraits of Anthony Cronin and Seamus Heaney and this was august company indeed.*

I had seen some portraits he had been commissioned to do of non-literary subjects. They were impeccable, as all Eddie's work was,

*but they lacked a certain flair, spark, perhaps
inspiration. His plant and bird studies always
had this last quality. I would not go so far as
to say that poets' conversations are more
stimulating than others' but Eddie seemed to
extract an extra, almost surreal dimension from
their presences and record it on canvas.*

*The sittings (and I think there were five)
took place in his seaside studio or, I should
say, laboratory. He worked from life and
photographs combined. the spectrum and I
suspect spectra of his own devising hung around
the walls, hundreds of slides, each with many
colour variations. This conglomeration of
rainbows, the smell of turpentine, paint, the
scatter of dead leaves, dead birds, books,
paintings and prints gave me the impression of
being in a fifteenth century Florentine studio.
We talked, discussed Andrew Wyeth and Francis
Bacon and poetry. Though I never saw the
canvas as work-in-progress, I was startled and
overwhelmed with the result. Eddie had not
seemed to be painting, just talking—and he
was an excellent conversationalist—but he had
caught me, bitterness, warts and all, on canvas.
I mourn him.'*

48

***Lobster—still life**. 1971
36 x 30. Oil on canvas.
Signed: Edward McGuire. 71.
Exhibited: RHA 1972, cat. 83; Artist's
 Choice, Ulster Museum 1973, cat. 5.
Private collection.
Provenance: Dawson Gallery; Carl Mullen;
 via auction; present owner.
*This still life of a lobster flanked by two crabs
and two chianti bottles, all supported on a chair
and table of oak, often used by the artist, has
been nicknamed 'the lobster crucifixion'. The
arrangement of the shell-fish, the fact that the
lobster is blue, not red as it would be if cooked,
the flanking crabs and the bottles leaning as
though in commiseration may have given rise
to this nickname. The shell-fish and the basket
came from the beaches beside the artist's summer
studio at Termon, Mahery, Donegal, where he
worked for several months each year from 1971
to 1980. The chianti bottles probably dated
from the artist's formative period in Italy in
the 1950s.*

49

Owl with Oak Leaves. 1972
Still life.
29 x 35. Oil on canvas.
Signed: Edward McGuire 1972.
Exhibited: RHA 1973, cat. 98, nfs.
Private collection.
Provenance: Dawson Gallery; present owner.
*First of the series of still lives using the tawney
owl as motif. The artist bought this stuffed owl
in 1952, twenty years before.*

50

Owl. 1972
Still life.
13 x 18. Oil on canvas.
Signed: Edward McG. 72.
Private collection.
Provenance: Dawson Gallery; present owner.

51

Owl. 1972
Still life.
12 x 9. Oil on panel.
Signed: EMcG. 72.
Exhibited: Artist's Choice, Ulster Museum
 1973, cat. 13.
Private collection.
Provenance: Dawson Gallery; owner.

52

***Owl II**. 1972
Still life.
36 x 25. Oil on canvas.
Signed: McGuire 72.
Exhibited: Oireachtas 1973, cat. 37, nfs;
 RTE film 1977; RHA, memorial section
 1988, cat. 245.
Private collection.
Provenance: Dawson Gallery; J. Stafford; via
 auction; present owner.
Tawney owl in landscape.

*The following entries—numbers 53-57—are
taken from studio records. Dawson Gallery
records being unavailable, they are listed
without details, as owners are not known.*

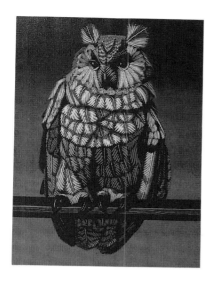

53
Owl. 1972
Still life.
Oil.
Private collection.
Provenance: Dawson Gallery; present owner.

54
Owl. 1972
Oil.
Private collection.
Provenance: Dawson Gallery; present owner.

55
Owl. 1972
Still life.
Oil.
Private collection.
Provenance: Dawson Gallery; present owner.

56
Owl. 1972
Still life.
Oil.
Private collection.
Provenance: Dawson Gallery; present owner.

57
Owl IV. 1972
Still life.
Oil.
Private collection.
provenance: Dawson Gallery; present owner.

58
Owl—Last. 1973
Still life.
36 x 24. Oil on canvas.
Signed: Edward McGuire 1973
Collection: P.J. Carroll
Provenance: Dawson Gallery; owner.

59
***Owl—Moonlight**. 1973
Still life.
40 x 50. Oil on canvas.
Signed: Edward McGuire 1973.
Exhibited: Artist's Choice, Ulster Museum
 1973, cat. 8. Sixth Festival International,
 Cagnes-sur-Mer 1974, cat. 131, diploma
 award, listed as 'Midnight Owl'; RTE film
 1977.
Private collection.
Provenance: Dawson Gallery; present
 owners.

60
***Portrait of Professor Jessop**.
1973.
34 x 30. Oil on canvas.
Signed: Edward McG. 73.
Collection: Trinity College, Dublin.
*This portrait of Dr W.J.E. Jessop, fellow
emeritus of TCD and President of the Royal
College of Physicians of Ireland, was
commissioned by friends and colleagues
on his retirement.*

61
***Portrait of Nuala**. 1973
36 x 24. Oil on canvas.
Exhibited: RHA 1974, cat. 28, nfs, RTE film
 1977.
Private collection.
Provenance: artist; owner.
*One of the artist's rare portraits of women.
Nuala Mulcahy is seated, hands folded, wearing
a brown dress with a background of narcissi.*

62
Kestrel. 1973
Still life.
36 x 28. Oil on canvas.
Private collection.
Provenance: Dawson Gallery; owner.

63
Parrot. 1973.
Still life.
18 x 14. Oil on canvas.
Private collection.
Provenance: Dawson Gallery; owner; Taylor
 Galleries; present owner.

64
Portrait of Catherine. 1974
36 x 24. Oil on canvas.
Signed: E. McGuire 1974.
Private collection.
Provenance: artist to owner.
*One of only six child portraits. Catherine
Harsch was the daughter of the photographer
who at this period was photographing the
artist's work. An account was outstanding
and this portrait was painted to pay it.*

65
***The Window**. 1974
Still life.
40 x 50. Oil on canvas.
Signed: Edward McGuire 1974.
Exhibited: RHA 1974, cat. 39, nfs; RTE film
 1977.
Private collection.
Provenance: Dawson Gallery; owner.
*This still life is of a six-paned sash window and
five birds—pheasant, kestrel, parrot, duck and
lapwing (plover). The window frame came from
the artist's Donegal studio.*

66
Kestrel. 1974
Still life.
12 x 9. Oil on panel.
Private collection.
Provenance: artist; owner.

66a
Head of a Bird. 1974
Still life.
12 x 9. Oil on canvas.
Exhibited: Art Inc., Guinness Hop Store,
 1991, cat. 59.
Collection: P.J. Carroll.
Provenance: Dawson Gallery; owner.

67
Lapwing. 1974
Still life.
9 x 12. Oil on panel.
Private collection.
Provenance: Dawson Gallery; owner; Taylor
 Galleries; owner.

68
***Portrait of Seamus Heaney**. 1974
56 x 44. Oil on canvas.
Signed: Edward McGuire 1974.
Exhibited: Oireachtas 1975, cat. 27,
 illustrated b/w; 'The Delighted Eye'
 1980, cat. 49, illustrated; 'Portraits of
 Irish Writers', Kerlin Gallery 1988, cat.
 49, illustrated b/w; RTE film 1971.
Collection: Ulster Museum, Belfast.
Provenance: commissioned by the Ulster
 Museum 1974.
*Portrait of the eminent Irish poet, born 1939,
member of Aosdána. See CAT 70.*

69
***Portrait of Francis Stuart**. 1974
30 x 25. Oil on canvas.
Signed: 1974. Edward McGuire.
Exhibited: RHA 1975, cat. 24; RTE film 1977.
Collection: Hugh Lane Municipal Gallery of
 Modern Art, Dublin.
Provenance: Dawson Gallery; Hugh Lane
 Municipal Gallery of Modern Art.
*Portrait of the novelist and poet, born 1902,
member of Aosdána.*

70
Portrait of Seamus Heaney. 1974.
12 x 9. 'Tempera' on panel.
Signed: EMcG 1974.
Collection: National Gallery of Ireland, cat.
 4112.
*Head and shoulders portrait of the poet (see
CAT. 68).*

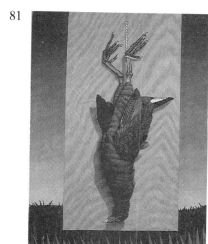

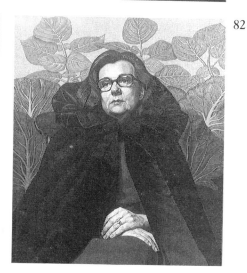

71
Portrait of Dr R.J. McConnell. 1975
29 x 25. Oil on canvas.
Signed: Edward McGuire.
Collection: Trinity College, Dublin.
Provenance: Dawson Gallery; owner.
Portrait commissioned by Trinity College,
 Dublin.

72
Portrait of Professor R.A.Q. O'Meara.
 1975
20 x 16. Oil on canvas.
Signed: E. McGuire.

Exhibited: RHA 1975, cat. 92, nfs.
Collection: Trinity College, Dublin.
Provenance: Dawson Gallery; TCD.
Professor O'Meara was an uncle of the artist's
family. He died before this (commissioned)
portrait was finished. But the artist had known
him so well that he was able to complete the
portrait.

73
Portrait of Doreen Mullen. 1975.
Oil on canvas.
Private collection.
Provenance: Dawson Gallery; owner.

74

Portrait of Hayden Murphy. 1975
12 x 9. Oil on panel.
Private collection.
Provenance: Dawson Gallery; owner.
Hayden Murphy, editor of Broadsheet, *poetry magazine.*

75

Portrait of Shane. 1975
36 x 24. Oil on canvas.
Exhibited: Ulster Museum, 1970.
Private collection.
Provenance: artist; owner.
The only known portrait of a boy by the artist, it was painted as an exchange for a head of the artist's step-daughter, Tresa (see CAT. *97) by Shane McDonnell's mother, sculptor Irene Broe.*

76

Portrait of Sonia. 1976
36 x 23. Oil on canvas.
Signed: E. McGuire. 1976.
Private collection.
Provenance: Dawson Gallery; owner.
Portrait of Sonia Rogers with her chihuahua dog. Only two other portraits include dogs (see CAT. *38 and 107).*

77

Portrait of Ulick O'Connor. 1976
20 x 16. Oil on canvas.
Exhibited: RHA 1976, cat. 139, nfs.
Private collection.
Provenance: Dawson Gallery; owner.
Portrait of the Irish writer, born 1929, member of Aosdána.

78

Portrait of Cearbhall Ó Dálaigh. 1976
26 x 22. Oil on canvas.
Signed: EM 76.
Exhibited: Oireachtas 1976, cat. 48, nfs,
 Douglas Hyde Gold Medal—Historical
 Section.
Collection: European Court of Justice in
 Luxembourg.
Provenance: Dawson Gallery; owner.
This portrait was commissioned by the Court while Cearbhall Ó Dálaigh was President of Ireland to hang in the Court in Luxembourg.

In the portrait he is dressed in the judicial robes of that court. Cearbhall Ó Dálaigh was president of Ireland, 1974-76.

79

Portrait of Cearbhall Ó Dálaigh. 1976
36 x 24. Oil on canvas.
Signed: E. McGuire. 76.
Collection: Taylor Galleries.
Provenance: on loan to the presidential
 rooms at the National Museum, Dublin.
This, his second portrait of the Irish president, was painted by the artist because the initial commissioned painting was for Luxembourg and would leave the country. This portrait has kindly been lent by the artist's agent, John Taylor, to the presidential room at the National Museum for the benefit of the nation.

80

Portrait of Monk Gibbon. 1976
36 x 23½. Oil on canvas.
Exhibited: RHA 1976, cat. 246, nfs; RTE
 film 1977.
Provenance: artist; owners.
William Monk Gibbon (1896-1987), writer of biography, autobiography, poetry and travel books, was a neighbour and friend of the artist from 1966 to 1986. He is painted with his cat, Percy.

81

Waterhen. 1976
Still life.
36 x 24. Oil on canvas.
Exhibited: RHA 1976, cat. 82, nfs.
Private collection.
Provenance: Dawson Gallery; owner.

82

Portrait of Eilís Dillon. 1976
36 x 24. Oil on canvas.
Signed: E. McGuire 1976.
Exhibited: Oireachtas 1977, cat. 40, nfs.
Private collection.
Provenance: Dawson Gallery; owner.
Portrait of the writer, Eilís Dillon wearing a Kinsale cloak. Author of novels, including Across the Bitter Sea, *and children's books, Eilís Dillon is a member of Aosdána.*

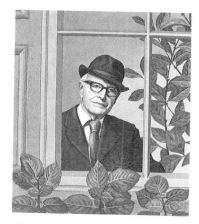

83
Portrait of Seán O'Faolain. 1977
30 x 25. Oil on canvas.
Signed: Edward McG. 1977.
Collection: National Gallery of Ireland.
Provenance: commissioned by a committee
organised by Seán Mulcahy and presented
to the National Gallery.
Seán O'Faolain, the Irish writer, born 1900 in
Cork, is a member of Aosdána and was elected
Saoi in 1986.

84
Seabird I. 1977
Still life.
20 x 16. Oil on panel.
Signed: EM 77.
Private collection.
Provenance: Dawson Gallery; owner.
One of a pair of razorbill painted in Donegal;
the ocean-living bird was washed up on the
beach beside the studio; the chair came from
a deserted island cottage.

85
Seabird II. 1977
Still life.
20 x 16. Oil on panel.
Signed: EM 77.
Private collection.
Provenance: Dawson Gallery; owner.
One of a pair of razorbill (see CAT. 84)

86
Portrait of Denis Larkin. 1977
26 x 22. Oil on canvas.
Exhibited: Oireachtas 1978, cat. 38, nfs.
Private collection.
Provenance: Dawson Gallery; owner; by
descent to present owner.
Portrait commissioned by An Foras Taluntais
and presented to Denis Larkin on his retirement.

87
Portrait of Dr D. McCarthy. 1977
36 x 24. Oil on canvas.
Collection: University College, Cork.
Provenance: artist; Dawson Gallery; owner.
Portrait commissioned by the governing body of
University College, Cork. Dr McCarthy was
President of the College from 1967 to 1978.

88
Portrait of Benedict Kiely. 1977
30 x 25. Oil on canvas.
Signed: EM 77.
Exhibited: 'Faces in a Bookshop', Kenny
Gallery 1990, cat. 66; 'Faces in a
Bookshop', National Library Dublin 1991.
Collection: Kenny's Gallery, Galway.
Provenance: Dawson Gallery; owner.
Portrait of the writer, a member of Aosdána.

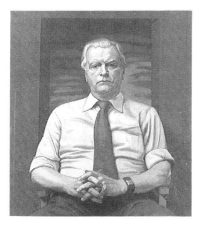

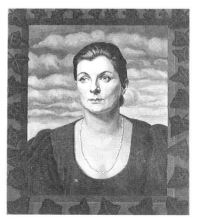

89
***Portrait of Anthony Cronin**. 1977
25 x 30. Oil on canvas.
Signed: E. McGuire. 77.
Exhibited: RHA 1978, cat. 103, nfs; RTE
 film 1977.
Private collection.
Provenance: Dawson Gallery; owner.
*Anthony Cronin poet and novelist and critic,
was born 1925 in Wexford. Currently Arts
Advisor to the Taoiseach, he is member of
Aosdána.*

90
Portrait of Terry Keane. 1977
36 x 24. Oil on canvas.
Exhibited: RHA 1979, cat. 116, nfs.
Private collection.
Provenance: artist; owner.

91
Blackbird on a Plate I. 1977
Still life.
Exhibited: RHA 1979, cat. 44, nfs.
Private collection.
Provenance: Dawson Gallery; owner.
One of a pair.

92
Blackbird on a Plate II. 1977
Still life.

24 x 18. Oil on panel.
Exhibited: RHA 1979, cat. 56, nfs.
Private collection.
Provenance: Dawson Gallery; owner.
One of a pair (see CAT. 91).

93
Portrait of Terry II. 1977
24 x 20. Oil on panel.
Signed: EM 77.
Exhibited: RHA 1979, cat. 138, nfs.
Private collection.
Provenance: artist; owner.
*This second portrait of the Irish journalist,
Terry Keane was painted because the artist
wished to portray a different facet of his sitter's
personality. It is his only painting with a frame
of painted foliage.*

94
Portrait of John Mulcahy. 1978
36 x 24. Oil on canvas.
Private collection.
Provenance: artist; owner.

95
Portrait of Charles J. Haughey, 1978
29 x 24. Oil on canvas.
Signed: EM 78.
Private collection.
Provenance: artist; owner.
*Charles J. Haughey, Taoiseach 1979-1981,
1982, 1987-. See also CAT. 108.*

96
***Portrait of Eamon Morrissey**. 1978
36 x 24. Oil on canvas.
Exhibited: RHA 1982, cat. 249, nfs.
Private collection.
Provenance: Taylor Galleries; owner.
Eamon Morrissey, actor and playwright,
seated astride a ladderbacked chair, with
plates and an iron kettle on the dresser
in the background.

97
***Portrait of Tresa**. 1978/80
30 x 25. Oil on canvas
Signed: EM 80.
Exhibited: RHA 1978, cat. 67, nfs.
Private collection.
Provenance: artist; owner.
Cork Rosc. 1980.
Portrait of Tresa Browne, born India 1963,
artist's step-daughter, wearing Hallow'een
costume. The portrait was begun when she was
eleven (1974) and finished when she was fifteen
(1978). The background clouds were altered in
1980, hence the dating.

98
Portrait of William Whitelaw. 1979
36 x 25. Oil on canvas.
Signed: EM 1979.
Private collection.
Provenance: artist; former Taylor Galleries;
 owner.
William Whitelaw, former MP and Secretary
of State for Northern Ireland. This portrait
was privately commissioned by his family.
The artist travelled to Cumbria in the north of
England to make studies for the portrait. Lord
Whitelaw is painted before a Georgian window
behind which an eagle stands.

99
Portrait of Muriel Gahan. 1979
12 x 9. Oil on panel.
Collection: Royal Dublin Society.
Provenance: commissioned by the Royal
 Dublin Society.
Dr Gahan was the first woman to be a
vice-president of the RDS. She pioneered
the Arts and Crafts movement in Ireland.

100
Portrait of Sir Alfred Beit and his wife
 Clementine. 1979
23 x 28. Oil on canvas.
Signed: EM 1979
Exhibited: RHA 1982, cat. 101, nfs.
Private collection.
Provenance: artist; Taylor Galleries; owner.
The second of only three known 'landscape
portraits' (see CAT. 38 & 107). The portraits
of Sir Alfred and Lady Beit are half length
and dominant in the foreground, either side of
the canvas. The landscape, receding behind
them, is of a lake with swans, meadows with
sheep and cattle and the Palladian house,
Russborough, which, together with part of their
important collection of paintings, they gave to
the nation in 1988.

101
Portrait of Margaret Downes. 1980
36 x 24. Oil on canvas.
Signed: EM 80.
Exhibited: Oireachtas 1980, cat. 39, nfs.
Private collection.
Provenance: artist; Taylor Galleries; owner.
Privately commissioned. Three-quarter length
portrait in patterned dress and background.
Margaret Downes is a prominent accountant
and company director.

102
Portrait of Dr Thomas Murphy. 1980
40 x 30. Oil on canvas.
Signed: EM 80.
Collection: University College Dublin.
Dr Thomas Murphy was President of
University College, Dublin, from 1972 to 1985.
This portrait was commissioned by UCD.

103
Portrait of Joan Ryan. 1980
30 x 25. Oil on panel.
Exhibited: RHA 1982, cat. 21, nfs.
Private collection.
provenance: artist; Taylor Galleries; owner.
Joan Ryan is the wife of former senator Eoin
Ryan. Privately commissioned.

104
Portrait of James White. 1981
29 x 24. Oil on canvas.

Signed: EM 1981.
Collection: National Gallery of Ireland, cat.
 4345.
Provenance: commissioned by National
 Gallery.
*Dr James White was director of the National
Gallery of Ireland from 1964 to 1981.*

105
***Portrait of Paul Durcan**. 1981
32 x 24. Oil on canvas.
Exhibited: RHA 1982, cat. 62, nfs; RHA,
 memorial section, 1988, cat. 248.
Private collection.
Provenance: Taylor Galleries; owner.
*Paul Durcan, poet, born Dublin, 1944, won
the 1990 Whitbread prize for poetry. He is
a member of Aosdána.*

106
Portrait of Paul Durcan. 1981
16 x 12. Oil on canvas.
Signed: EM 81.
Private collection.
Provenance: Taylor Galleries; owner.

107
Equestrian Portrait, Abbeville.
26 x 48. Oil on canvas. 1981.
Signed: EM 81.
Private collection.
Provenance: artist; owner.
*The last of only three known landscape
portraits. (see CAT. 38 and 100) This painting
is of the Taoiseach, Charles J. Haughey, TD
on his hunter, Barry, with a wolfhound and his
home, Abbeville, with stableyard by architect
Richard Gandon.*

108
Portrait of Charles J. Haughey TD. 1981
17 x 14. Oil on canvas.
Private collection.
Provenance: artist; owner.
*This portrait is the only known profile in oils by
the artist.*

109
Portrait of Liam Cosgrave. 1982
50 x 40. Oil on canvas.
Collection: Office of Public Works.

Provenance: commissioned by the office of
 public works.
Portrait of the former Taoiseach 1973-75.

110
Portrait of William McEnery. 1982
24 x 18. Oil on panel.
Private collection.
Provenance: artist; owner.
*William McEnery, father of Eamonn, whose
uncle owned Rossenarra (see CAT. 38).*

111
Portrait of Vincent Poklewski-Kozeill.
 1982
12 x 9. Oil on panel.
Signed: EM 82
Private collection
Provenance: Taylor Galleries; owner.

112
Portrait of Sean White. 1982
24 x 18. Oil on panel.
Exhibited: RHA 1984. cat. 106. nfs.
Private collection.
Provenance: artist; owner.

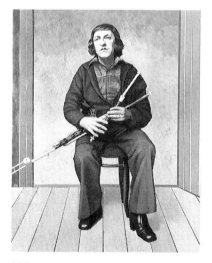

113
Portrait of Paddy Moloney—the Piper.
 1982
30 x 24. Oil on panel.
Signed: EM 82.
Inscribed reverse: Paddy Moloney (Piper) by
 E. McGuire RHA oil 1982.

Exhibited: RHA 1982, cat. 1, nfs.
Private collection.
Provenance: artist; Solomon Gallery; James
 Adam auction 1983; owner.
*Paddy Moloney—the piper of 'The Chieftains',
traditional Irish musicians (see CAT. 39)—with
his uillean pipes seated on a bentwood chair in
the open door of an upper barn. Full-length
portrait.*

114
Portrait of Paddy Moloney. 1982
12 x 9. Oil on panel.
Signed: EM 82.
Private collection.
Provenance: Apollo Gallery; Ruadhan
 Donnelly.

115
Portrait of Paddy Moloney. 1982
12 x 9. Oil on panel.
Signed: EM 82.
Private collection.
Provenance: artist; owner.

116
Portrait of Ivor Brown. 1982
30 x 24. Oil on canvas
Private collection.
Provenance: Taylor Galleries; owner.
Ivor Brown is a prominent Dublin psychiatrist.

117
Portrait of Conor Crowley. 1982
36 x 26. Oil on canvas.
Private collection.
Provenance: Taylor Galleries; owner.

118
Portrait of Clodagh King. 1982
24 x 18. Oil on panel.
Private collection.
Provenance: artist; owner.
*Clodagh King of Achill Island is a cousin of the
artist.*

119
Portrait of Dr Ivor Kenny. 1982.
28 x 21. Oil on panel.
Exhibited RHA 1982, cat. 29, nfs.
Private collection.

Provenance: Taylor Galleries;
*Commissioned by members of the Irish
Management Institute and presented to
Dr Kenny, its Director General.*

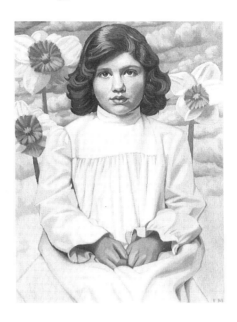

120
Portrait of Emma. 1982
24 x 18. Oil on panel.
Exhibited: RHA 1983, cat. 56, nfs.
Private collection.
Provenance: artist; owner.
*Emma Stewart is the daughter of Sylvia and
Norman Stewart, neighbours of the artist in
Sandycove; one of only six child portraits.*

121
Portrait of Liam Miller. 1982
26 x 24. Oil on canvas.
Signed: EM 1982.
Exhibited: RHA 1983, cat. 104, nfs.
Private collection.
Provenance: Taylor Galleries; owner.
Liam Miller was publisher of the Dolmen Press.

122
Portrait of W. Abbott. 1982
24 x 18. Oil on panel.
Private collection.
Provenance: artist; owner.
Private commission.

123
Portrait of Ciaran MacMathuna. 1982
24 x 18. Oil on panel.
Exhibited: RHA 1983, cat. 120, nfs.
Private collection.
Provenance: artist; owner.
Ciaran MacMathúna, born 1925, is an authority on traditional Irish music, and a well-known broadcaster.

124
Portrait of John Jordan. 1982
25 x 19. Oil on panel.
Signed: EM 82.
Exhibited: RHA 1983, cat. 50, nfs.
Private collection.
Provenance: Taylor Galleries; owner.
John Jordan (1930-88), critic, lecturer, poet and writer, was a member of Aosdána.

125
Portrait of Ann Reihill. 1982
36 x 25. Oil on canvas.
Signed: EM 82
Private collection.
Provenance: Taylor Galleries; owner.
Ann Reihill, publisher, is editor of the Irish Arts Review. *Private commission.*

126
Portrait of Astrid. 1983
24 x 18. Oil on panel.
Signed: EM 83.
Private collection.
Provenance: artist; owner.
Astrid McGuire, niece of the artist.

127
Portrait of Rebecca. 1983
36 x 28. Oil on canvas.
Signed: EM 1983.
Exhibited: RHA 1983, cat. 113, nfs, entitled 'Sweet Dreams Rebecca'.
Private collection.
Provenance: artist; owner.
One of only six child portraits; Rebecca O'Mara is a cousin of the artist.

128
***Portrait of John Montague**. 1983
32 x 27. Oil on panel.
Signed: EM 1983.
Exhibited: 'Portraits of Irish Writers', Ulster Museum 1985; 'Portraits of Irish Writers', Kerlin Gallery Dublin 1988, cat. 36.
Collection: Ulster Museum, Belfast.
Provenance: Taylor Galleries; Ulster Museum.
John Montague, born in New York 1929, poet and academic, is a member of Aosdána.

129
Portrait of Brian Fallon. 1983
24 x 18. Oil on panel.
Signed: EM 83.
Exhibited: RHA 1983, cat. 157, nfs.
Private collection.
Provenance: Taylor Galleries; owner.
Brian Fallon, art historian, is chief art critic of the Irish Times.

130
Portrait of Patrick Collins. 1983
27 x 24. Oil on canvas.
Signed:
Exhibited: RHA 1984, cat. 143, nfs.
Private collection.
Provenance: Taylor Galleries; owner.
Patrick Collins, born in Co. Sligo 1911,
painter, is a member of Aosdána and was
elected Saoi in 1987.

131
Portrait of Patrick Collins. 1983
25 x 19. Oil on panel.
Signed; EM 83.
Private collection.
Provenance: Taylor Galleries; owner
See note on CAT. 130.

132
Chough I. 1983
Still life
18 x 24. Oil on panel.
Exhibited: Taylor Galleries 1983, one-man
 exhibition of seven works.
Private collection.
Provenance: Taylor Galleries; owner.
One of a pair of paintings distinct in that one is
of the female chough, the other, the male
Chough. The chough is a rare bird, still extant
in Co. Kerry.

133
Clough II. 1983
Still life
18 x 24. Oil on panel.
Exhibited: Taylor Galleries 1983, one-man
 exhibition of seven works.
Private collection.
Provenance: Taylor Galleries; owner.
One of a pair of paintings. See note on CAT.
 132.

134
Portrait of Bob Willis. 1983
34 x 26. Oil on canvas.
Private collection.
Provenance: Taylor Galleries; owner.
Robert (Bob) Willis, is a former Director of the
Irish Life Assurance Co.

135
***Portrait of Michael Longley.** 1983
32 x 24. Oil on panel.
Signed: EM.
Exhibited: Taylor Galleries 1983, one-man
 exhibition of seven works.
Private collection.
Provenance: Taylor Galleries; owner.
Michael Longley, poet, born in Belfast 1939, is
Combined Arts Director of the Arts Council of
Northern Ireland.

 In a letter dated Christmas Day 1990 to
Sally McGuire, Michael Longley writes:
'I had been working for a long time and without
success on a different approach to a poem for
Eddie. Then the enclosed [the poem on page
102 above] just presented itself a couple of days
ago. Eddie painted my eyes blue instead of
brown! And in a couple of boozy phone calls
refused to admit the mistake—though, sober, he
promised to rectify the error. Now, I wouldn't
have the picture any other way—the only
portrait is one in which I have blue eyes!

 I often think of Eddie and appreciate more
and more that I am one of his subjects. He
was a superb painter and interpreter of human
personality: a great man. As the rest of the
world will be, I am grateful to you for all
you are doing for the man and his pictures.

 If you don't like my poem, please say so,
and I'll try to come up with something else.
Indeed, if there's any way I can be helpful,
let me know.

 My first slim volume in twelve years emerges
at the end of March: Gorse Fires. 'sitting for
Eddie' is the first new poem since I put Gorse
Fires to bed— a blessing and a challenge to
keep writing. . . '.

136
Portrait of Michael Longley. 1983
16 x 12. Oil on panel.
Singed: EM. 83.

Exhibited: Taylor Galleries 1983, one-man
 exhibition of seven works
Private collection.
Provenance: Taylor Galleries; owner.
See note on CAT. *135.*

137
Portrait of Julia O'Faolain. 1983
16 x 12. Oil on panel.
Signed: EM 83.
Inscribed reverse: 'Julie by E. McGuire
 1983.' Oil on board.
Private collection.
Provenance: Taylor Galleries; owner.
Julia O'Faolain, novelist and member of
Aosdána, is depicted against a background
of Clematis flowers.

138
Chough. 1983
Still life.
24 x 18. Oil on panel.
Signed: EM.
Private collection.
Provenance: Taylor Galleries; owner.
See note on CAT. *132.*

139
Portrait of Sydney Bernard Smith. 1983
25 x 19. Oil on panel.
Signed: EM 83.
Private collection.
Provenance: Taylor Galleries; owner.
Sydney Bernard Smith, born 1936, poet,
playwright and actor, is a member of Aosdána.

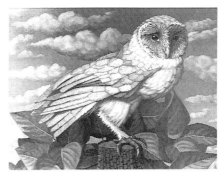

140
Owl. 1983
Still life.
24 x 32. Oil on canvas.
Signed: EM.
Collection: Hugh Lane Municipal Gallery
 of Modern Art, Dublin.
Provenance: Taylor Galleries; Hugh Lane
 Municipal Gallery of Modern Art.
This painting is first in a series of the white
barn owl continuing until 1985.

141
Owl. 1983
Still life.
24 x 18. Oil on canvas.
Private collection.
Provenance: Taylor Galleries; owner.
Barn owl on green table; background sky
with clouds.

142
Barn Owl. 1983
Still life.
Oil on canvas.
Private collection.
Provenance: Taylor Galleries; owner.

143
Owl. 1983
Still life
18 x 24. Oil on panel.
Signed: 1983 Edward M.
Inscribed reverse: Barn Owl Oil Edward
 McGuire. 1983'.
Private collection.
Provenance: Taylor Galleries; owner.

144
Owl. 1983
Still life.
12 x 9. Oil on panel.
Private collection.
Provenance: Apollo Gallery; owner.

145
Portrait of Julia O'Faolain. 1984
24 x 18. Oil on panel.
Signed: EM 84.
Private collection.
Provenance: artist; Apollo Gallery; owner.
See the note on CAT. 137.

146
Asters. 1984
Still life.
24 x 18. Oil on panel.
Signed: EM 84.
Inscribed reverse: 'Still life, E. McGuire
 RHA 1984'.
Private collection.
Provenance: Taylor Galleries; owner.
*This still life is the only known flowerpiece by
the artist. Asters in a white enamel jug against
a plain background.*

147
Owl. 1984
Still life.
11 x 13. Oil on panel.
Signed: EM 84.
Private collection
Provenance: Taylor Galleries; owner.

148
Owl. 1984
Still life
23 x 19.
Private collection.
Provenance: Taylor Galleries; owner.

149
Barn Owl. 1984
Still life.
38 x 50. Oil on canvas.
Private collection.
Provenance: Taylor Galleries; owner.

150
Portrait of Seán MacBride. 1984
32 x 24. Oil on canvas.
Exhibited: RHA 1985, cat. 118, nfs.
Signed: EM 1984.
Private collection.
Provenance: Taylor Galleries; owner.
*Seán MacBride (1904-88), Irish politician and
world statesman, was awarded the Nobel Prize
for Peace in 1974.*

151
Portrait of Seán MacBride. 1984
12 x 16. Oil on panel.
Private collection.
Provenance: Taylor Galleries; owner.
See CAT. 151.

152
Mummified Cat. 1984
Still life.
24 x 36. Oil on panel.
Signed: EM 1984.
Exhibited: RHA 1985, cat. 133, nfs, 'Dead
 Cat'.
Private collection.
Provenance: Taylor Galleries; owner.
*The subject, unique in the artist's oeuvre, was
found in the old dairy of the Wicklow farm
cottage where the artist worked 1980-81.*

153
Barn Owl. 1985
Still life.

12 x 9. Oil on panel.
Signed: EM 85.
Inscribed reverse: Astrid & Michael.
Private collection.
Provenance: artist; owners.

154
***Barn Owl**. 1985
Still life
24 x 18. Oil on panel.
Signed: EM 85.
Private collection.
Provenance: Taylor Galleries; owner.
*As in others of this series of barn owls, this
one has lilac leaves below the owl. A lilac tree
grows outside the window of the artist's studio
at Sandycove.*

155
Barn Owl. 1985
Still life.
48 x 36. Oil on canvas.
Signed: E. McGuire. 85.
Private collection.
Provenance: Taylor Galleries; present owner.

156
Portrait of Patrick Donegan. 1986
24 x 18. Oil on panel.
Signed.
Collection: National Institute of Higher
 Education, now Dublin City University.
Provenance: Taylor Galleries; owners.
*Patrick Donegan, former Chairman of the
Governing Body of NIHE.*

157
Portrait of Dr Terry Larkin. 1986
Unfinished. 24 x 18. Oil on panel.
Unsigned.
Collection: National Institute of Higher
 Education, now Dublin City University.
Provenance: artist's studio; via Taylor
 Galleries; owners.
*Terry Larkin was Chairman of the Governing
Body of NIHE.*

158
Portrait of Michael McCormack. 1986
Unfinished. 24 x 18. Oil on panel.
Unsigned.

Collection: National Institute of Higher
 Education, now Dublin City University.
Provenance: artist's studio via Taylor
 Galleries; owners.

159
Duck. 1986
Still life
9 x 12. Oil on panel.
Signed: EM 86.
Inscribed reverse: Duck. Oil by E. McGuire
 RHA 1986.
Private collection.
Provenance: artist; owner.

160
Duck. 1986
Still life.
18 x 24. Oil on panel.
Signed: EM 86
Private collection.
Provenance: Taylor Galleries; owner.

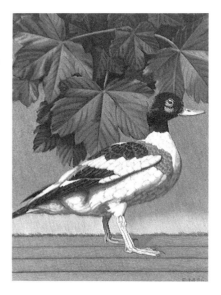

161
Duck. 1986
Still life.
24 x 18. Oil on panel.
Signed: EM 86.
Private collection.
Provenance: artist; Christopher Hull Gallery,
 London; owner.

162
Portrait of John Hume. 1986
Unfinished. 40 x 30. Oil on canvas
Unsigned.
Private collection.
Provenance: artist's studio; owner.
John Hume is the prominent Northern Irish politician, MP, MEP. Private commission.

163
Portrait of Maurice Craig. 1986
 Unfinished.
24 x 18. Oil on panel.
Unsigned.
Private collection.
Provenance: artist's studio;
Maurice Craig, architectural historian and writer.

164
Portrait of John McNamee. 1986
Unfinished. 12 x 9. Oil on panel.
Unsigned.
Private collection.

Provenance: artist's studio; owner.
John McNamee, born 1946, is a poet and writer.

165
Portrait of Patrick MacEntee. 1986
Unfinished. 24 x 18. Oil on panel.
Unsigned:
Private collection.
Provenance: artist's studio; owner.
Patrick MacEntee is a prominent senior counsel.

166
Portrait of Tony O'Riordan. 1986
Unfinished. 20 x 16. Oil on canvas.
Unsigned.
Private collection.
Provenance: artist's studio; owner.

167
Portrait of Maureen Charlton. 1986
Unfinished. 24 x 18. Oil on panel.
Unsigned.
Private collection.
Provenance: artist's studio; owner.

DRAWINGS

168
Self-portrait. 1955
10 x 10. Pencil on paper.
Inscribed reverse: 'Self portrait 1955 to Sara
 McGuire from Edward McGuire 1971'.
Private collection.
Provenance: artist; owner.
Three studies framed together.

169
Duck. 1959
Still life
9 x 7. Pencil on paper.
Signed: EM 59.
Collection: Glebe Gallery

170
Self-portrait. 1960
7 x 6. Pencil on paper.
Signed: EM 60.
Private collection.
Provenance: Dawson Gallery; owner.

171
Portrait of Barry Fitzgerald. 1960
Pencil on Paper.
Provenance: letter from Barry Fitzgerald to
 the artist dated 1960.
Barry Fitzgerald, the Irish actor, and the artist were house guests at Rock House in Co. Mayo. (see CAT. 21) Their host, Eamonn McEnery, remembers the portrait being drawn.

172
Two Woodcook. 1960
Still life.
14 x 20. Ink & wash on paper.
Signed: EM 1960.
Private collection.
Provenance: artist; owner.
In this wash drawing the 'painter's feather' of the woodcock was used as a brush. Two separate drawings framed together.

173
Portrait of Patrick Kavanagh. 1962
6 x 4. Pencil on paper.
Signed: EM
Private collection.
Provenance: artist; John Jordan; estate of
 John Jordan.

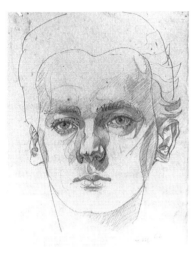

174
Study for Self-portrait. 1962
8 x 6. Pencil on paper.
Signed: EM 62.
Exhibited: Claddagh Records group
 exhibition, David Hendriks Gallery 1970,
 cat. 23.
Privately owned.
Provenance: David Hendriks Gallery; owner
 1970.

175
Self-portrait. 1965
8 x 6. Pencil on paper
Signed: EM 65
Inscribed reverse: 'to Allan Bell from
 Edward McGuire 25th Feb. 1971'.
Private collection.
Provenance: artist; owner.

176
Portrait of E.A. McGuire
10 x 7. Pencil on paper.
Private collection
Provenance: artist; owner.
Pencil sketch of the artist's father.

177
Woodcock. 1970
Still life
4 x 6. Pencil on paper.
Inscribed reverse: 'for Sally from Edward
 1973. From Edward McGuire 3/7/74'.
Private collection
Provenance: artist; owner.

178
Owl with Daisies. 1970
Still life
3½ x 6. Pencil on paper.
Signed: EM 70.
Private collection.
Provenance: artist; owner.

179
Owl. 1971
Still life
9 x 8½. Pencil on paper.
Signed: EM 71.
Inscribed reverse: 'For Sara. From Edward.
 Owl. Edward McGuire 1972'.
*Detailed pencil drawing, study for the series of
tawny owls painted during the 1970s (see CAT.
47).*

180
Owl Three. 1971
Still life.
8 x 10. Ink on paper.
Private collection.
Provenance: Dawson Gallery; owner.

181
Owl. 1971
Still life.
10 x 8. Pencil on paper.
Private collection.
Provenance: Dawson Gallery; owner.

182
Owl. 1972
Still life
10 x 7½. Ink on paper.
Signed: EMcG 72.
Private collection.
Provenance: artist; owner.

183
Owl. 1972
Still life
12 x 8. Ink on paper.
Signed: EMcG.
Private collection.
Provenance: artist; owner.

184
Portrait of Robert Goulet. 1972
9 x 6. Sepia wash drawing on paper.
Signed: EM 72.
Private collection.
Provenance: artist; owner.
*Robert Goulet, French-Canadian writer, born
1925, the brother-in-law of the artist's wife.
The drawing was done in Mallorca during a
visit in 1972.*

185
Owl. 1972
Still life.
11 x 6½. Pencil on paper.
Signed: EM 72.
Privately owned.

186
Owl—Moonlight. 1973
Still life.
10 x 8. Ink on paper.
Signed: EM 73.
Private collection.
Provenance: Dawson Gallery; owner.
*Study for the painting 'Owl—Moonlight' (see
CAT. 59)*

187
Portrait of Francis Stuart. 1973
Ink on paper.
Private collection.
Reproduced in Broadsheet, *No. 20, 1973:
ink drawing of the head of the writer, Francis
Stuart (see* CAT. *69).*

188
Portrait of Francis Stuart. 1974
12 x 9. Ink on paper.
Signed & dated.
Collection: Ulster Museum.
Provenance: Dawson Gallery 1974; owners.
Study for 'Portrait of Francis Stuart' (see CAT.
69)

189
Owl. 1974
Ink on paper.
Private collection.
Reproduced in a special edition of Broadsheet,
*1974. Owl with central panel containing excerpt
from a poem by George Meredith— 'Love in
the Valley'. 'For Edward and Sally Maguire
[sic] c.1974. Ltd. no. ed. 250. No. 39.
Surrounded by poems about owls by classic poets
including Tennyson, Byron, Grey, Byron,
Shakespeare and the editor of* Broadsheet,
Hayden Murphy.

190
Self-portrait. *c.*1975
8½ x 5½. Pencil on paper.
Private collection.
Provenance: artist; owner.

191
Portrait of Hayden Murphy. *c.*1975
Ink on paper.
Private collection.
Reproduced, specially drawn for Broadsheet
(see CAT. *74).*

192
Portrait of Monk Gibbon. 1976
12 x 9. Charcoal on paper.
Signed: EM 74.
Inscribed reverse: Edward McGuire.
Private collection.
Provenance: Dawson Gallery; owner.
*Study for 'Portrait of Monk Gibbon' (see
CAT. 80)*

193
Waterhen. 1976
Still life
9½ x 4. Ink & sepia wash drawing.
Unsigned.
Private collection.
Provenance: artist; Margaret West; owners.
Gift from the artist to his mother-in-law.

194
Portrait of John Jordan. 1982
8 x 6. Ink on paper.
Signed: EM 82.
Private collection.

Provenance: Taylor Galleries; owner.
Study for 'Portrait of John Jordan' (see CAT. 124).

195
Martello Tower. 1982
Landscape.
8½ x 7. Pencil on paper.
Signed: EM 82.
Private collection.
Provenance: artist's studio; owner.

196
Martello Tower—Sandycove. 1982
Landscape.
8½ x 7. Ink on paper.
Signed: EM.
Private collection.
Provenance: artist's studio.

197
Portrait of Rebecca. 1983
8 x 6. Pencil on paper.
Unsigned.
Private collection.
Provenance: artist; owner.
Study outline drawing for 'Portrait of Rebecca' (see CAT. 127).

198
Portrait of John Jordan. 1982
9 x 6½. Ink on paper.
Unsigned.
Private collection.
Provenance: artist's studio; owner.
Study drawing for 'Portrait of John Jordan' (see CAT. 125)

199
Owl. 1983
Still life.
Pen on paper.
Private collection.
Inscribed: 'For Macdara— Eiléan 1983'.
Barn owl. Reproduced in Cyphers, *Summer 1983, pp. 53.* Cyphers *is an occasional publication on literature and the arts. Macdara Woods and Eiléan Ní Chuilleanáin were personal friends of the artist.*

200
Killiney Obelisk. 1983
Landscape.
9 x 6. Ink on paper.
Signed: EM.
Private collection.
Provenance: artist's studio.

201
Portrait of Patrick Collins. 1983
11 x 8. Ink on paper.
Unsigned.
Private collection.
Provenance: artist's studio; owner.
Outline study for 'Portrait of Patrick Collins' (see CAT. 130).

202
Portrait of Sean MacBride. 1984
11 x 8. Ink on paper.
Signed: EM 84 ©
Inscribed: front: 'Sean MacBride 84'; reverse: 'E. McGuire RHA 1984 Sean MacBride © Indian Ink'.
Private collection.
Provenance: Joe Mullen's auction 1990; owner (see cat. 150).

203
Portrait of John Jordan. 1984
7 x 3½. Ink on paper.
Provenance: inscribed by John Jordan: 'Aosdána, 25th October 1984. By Edward McGuire'.
Drawing made at an Aosdána meeting (see CAT. 124). Sketch.

204
Barn Owl. 1984
Still life
8 x 7H. Pencil on paper.
Signed: EM 84.
Inscribed reverse: 'Barn owl 1984. E. McGuire'.
Private collection.
Provenance: artist; owner.
Detailed pencil drawing, study for the series of barn owls painted daring the 1980s (see CAT. 140).

205
The Cat. 1984
8 x 11. Ink on paper.
Unsigned.
Private collection.
Provenance: artist's studio; owner.
Sketch for still life 'Mummified Cat' (see CAT. 153).

206
Portrait of John McNamee. 1986
10 x 8. Ink on paper.
Unsigned.
Private collection.
Provenance: artist's studio; owner.
Outline study drawing for unfinished 'Portrait of John McNamee' (see CAT. 164).

207
Portrait of Maria. 1986
11 x 9. Pencil on paper.
Unsigned.
Private collection.
Provenance: artist's studio; owner.
Annotated working drawing for proposed portrait of Maria Muffet.

208
Portrait of Bruce Arnold. 1986
11 x 8. Pencil on paper.
Unsigned.
Private collection.
Provenance: artist's studio, owner.
Annotated, very detailed working drawing for proposed portrait of the art historian and journalist, born 1936.

209
Portrait of Maurice Craig. 1986
11 x 8. Pencil on paper.
Unsigned.
Private collection.
Provenance: artist's studio; owner.
Annotated working drawing for unfinished portrait (see CAT. 163).

210
Portrait of Patrick Gallagher. 1986
11 x 8. Blue ink on paper.
Unsigned.
Private collection.
Provenance: artist's studio; owner.
Outline drawing for proposed portrait of the journalist and broadcaster.

211
Portrait of Patrick Gallagher. 1986
11 x 9. Ink on paper.
Unsigned.
Private collection.
Provenance: artist's studio; owner.
Outline profile drawing (see CAT. 206).

SELECT BIBLIOGRAPHY

ARNOLD, BRUCE, *A Concise History of Irish Art*, revised editor, London, 1977, p. 167.

BARRET, CYRIL, 'Sitters', in Roderick Knowles, *Contemporary Irish Art*, Dublin, 1982, pp. 32f.

BOYLAN, HENRY, *A Dictionary of Irish Biography*, second edition, Dublin, 1988, p. 222.

CHARLTON, HUGH, 'Talks with Edward McGuire', *Martello* (Dublin), summer 1988, pp. 22-25.

COLLINS, PENELOPE, 'An Appreciation of Edward McGuire', *Martello*, summer 1988, pp. 15f.

CONNEALY, TERENCE, 'An Artist in Search of a Style', *Hibernia*, (Dublin) December 1969.

COOKE, HARRIET, 'Harriet Cooke talks to the Painter' *Irish Times*, April 1973.

FITZ-SIMON, CHRISTOPHER, *The Arts in Ireland: A Chronology*, Dublin 1982.

HARSCH, JONATHAN, 'Edward McGuire: The Choice of Painting', *Magill* (Dublin) 1969.

JORDAN, JOHN, 'Edward McGuire', essay for catalogue: *The Irish Imagination, Rosc 1971*, 86.

MACDAIBHEID, DIARMAID, 'Edward McGuire ag labhairt le Diarmaid Mac Daibheid', *Inniu* (Dublin) eanair, 1979.

MCGUIRE, EDWARD, 'Owl', *Image* (Dublin), July 1982.

MCGUIRE, EDWARD, 'Patrick Collins & Peter Pearson', *Martello*, winter 1982, pp. 1-4.

MCGUIRE, EDWARD, 'The Art of Portraiture', *Martello*, summer 1983, pp. 31-34.

MCGUIRE, SALLY, 'Edward McGuire's Portraits of Children', *Martello*, summer 1988, pp. 1-6.

MCGUIRE, SALLY, 'Portrait of Monk Gibbon', *Martello*, summer 1988, pp. 19f.

MURPHY, HAYDEN, 'Edward McGuire: A Profile', *The Arts in Ireland*, vol. 2, no. 4 (Dublin, 1974), pp. 38-48.

RUANE, FRANCES, introduction to catalogue: *The Delighted Eye, Irish Painting and Sculpture of the Seventies*, 1980, pp. 14, 16-17.

RYAN, SEBASTIAN, 'Edward', *Martello*, summer 1988, pp. 9-11.

WALKER, DOROTHY, 'Sailing to Byzantium: The Portraits of Edward McGuire', *Irish Arts Review*, vol. 4, no. 4, winter 1987, pp. 21-29.

INDEX

0009-2892-0999